Orangeville Ontario Beginnings in Colour Photos, Saving Our History One Photo at a Time

Photography
by Barbara Raué
2013

Series Name:
Cruising Ontario

Book 50: Orangeville Beginnings

Cover photo: 62 Mill Street – Italianate – wrap-around verandah, paired cornice brackets, dichromatic brickwork

Series Name: Cruising Ontario

Now in colour
Check the Appendixes in the back of each book for descriptions of architectural terms and building styles

- Book 33: Southampton
- Book 34: Jarvis
- Book 35: Hagersville
- Book 38: Cambridge Part 1 – Galt Book 1
- Book 39: Cambridge Part 1 – Galt Book 2
- Book 40: Cambridge Part 2 – Preston
- Book 41: Cambridge Part 3 – Hespeler
- Book 42: Kitchener Book 1
- Book 43: Kitchener Book 2
- Book 50: Orangeville Beginnings
- Book 51: Orangeville on Broadway

Other Books by Barbara Raue

Coins of Gold

Arrows, Indians and Love

The Life and Times of Barbara
Volume 1: Inventions That Have Enhanced My Life
Volume 2: Entertainment That I Have Enjoyed
Volume 3: East Coast Trips
Volume 4: Olympics
Volume 5: Wonders of the World
Volume 6: Caribbean Cruises
Volume 7: Animals
Volume 8: Storms
Volume 9: Wars

The Cromwell Family Book

Visit Barbara's website to view all of her books
http://barbararaue.ericraue.com

Orangeville

John Corbit acquired land in the area in 1829 and is one of the earliest settlers. Spring Brook, a tributary of the Credit River, provided water for power for several mills located downstream.

In 1833 Seneca Ketchum bought 200 acres on the north side of what became Broadway, followed four years later by George Grigg who bought 100 acres on the south side. By 1844 when Orange Lawrence and his wife, Sarah, arrived from Connecticut, a well-established community called Grigg's Mill existed beside Mill Creek. (Mill Creek and Spring Brook were the same tributary of the Credit River.)

Orange Lawrence helped to develop the community. He bought 300 acres, laid out the southeast part of town, bought Grigg's Mill, opened a general store and a tavern, built a second mill, founded the first school, and became the village's first postmaster in 1847. He left a strong mark on the community which took the appropriate name of Orangeville.

Immigrants from Ireland and other parts of the British Isles and Canada West came throughout the 1840s and 1850s with some establishing successful mixed farms while others settled in the village and became the landowners, merchants, and tradesmen whose needs lead to the development of good transportation routes.

By the 1860s it was increasingly difficult to deliver and receive goods to and from the supply centres in the south. Mono Road, Centre Road, Trafalgar Road, and the Toronto to Owen Sound Road were gravel roads that were difficult to traverse by horse and wagon for much of the year. Winter was the season when most goods were transported by sleigh over frozen roads.

By 1871 two daily stage lines were operating between Orangeville and Brampton, and that year the Toronto, Grey and Bruce Railway, a narrow gauge rail line, reached Orangeville, thanks to the efforts of town fathers such as Jesse Ketchum Jr., Samuel and Robert McKitrick, Johnston Lindsey, Thomas Jull, John Foley, and Dr. William Armstrong.

By 1875 there was a foundry, three planing mills, two saw mills, a tannery, a carding mill, several carriage and wagon manufacturers, and a successful pottery business in operation, along with four grocers, three hardware merchants, two drugstores, three watchmakers, three bakeries, and three establishments providing boots and shoes.

It was the foresight of Orange Lawrence and Jesse Ketchum that had large sections of land on either side of the main street laid out for both commercial and residential building lots. The south side followed Mill Creek while a regular grid pattern was determined for the streets on the north side from First to Fifth Streets both east and west and north to Fifth Avenue, with a wide main street called Broadway. This 30-metre (100-foot) avenue was not typical of Ontario towns of the time, but has proven to be very valuable over the years. In 1875 the Town Hall was constructed, and in 1887 the first telephone exchange was established, but it wasn't until 1916 that electricity came to the town.

The old town of Orangeville is still alive today. Some of the buildings on Broadway have been demolished; others have been renovated, while others remain as they were when they were built 120 years ago.

There are hundreds of old buildings in Orangeville which have retained their 1800s architectural styles and character. The first Orangeville book covers the beginnings of Orangeville with pictures from the south side of town, and buildings on Broadway. An appendix is included to describe architectural styles and terms which are referred to throughout the book. The second book covers buildings to the north of the town, as well as pictures taken in surrounding villages of Laurel, Caledon Village and Mono Centre.

Table of Contents

Beginnings of Orangeville Page 7
 Bythia Street
 York Street
 Little York Street
 John Street
 Mill Street
 Wellington Street
 Church Street
 Armstrong Street

Architectural Terms Page 53

Orangeville's Building Styles Page 55

Beginnings of Orangeville – Bythia Street

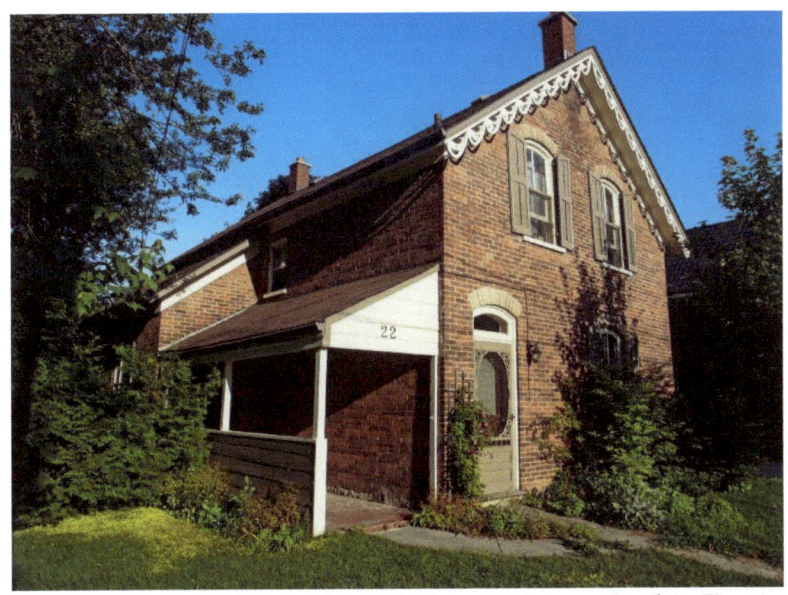

22 Bythia Street – Vergeboard decoration – Gothic Revival

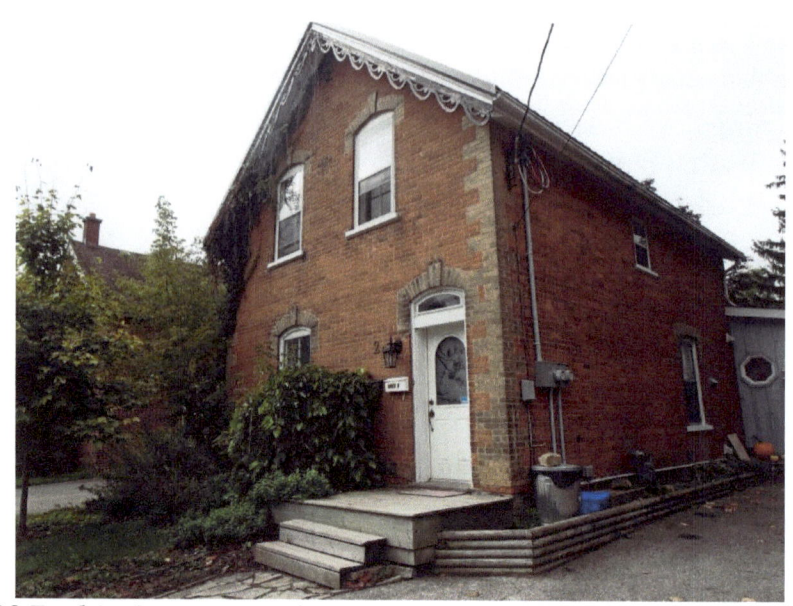

20 Bythia Street – Gothic Revival – dichromatic brickwork

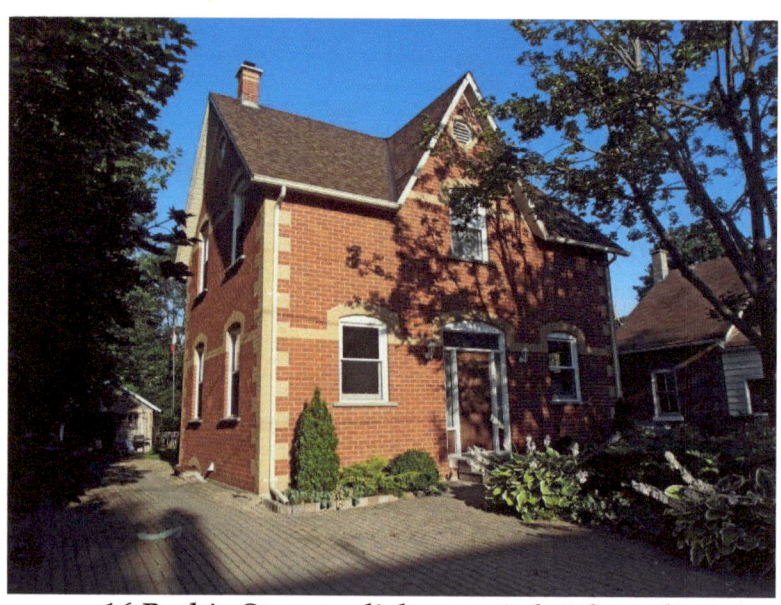

16 Bythia Street – dichromatic brickwork

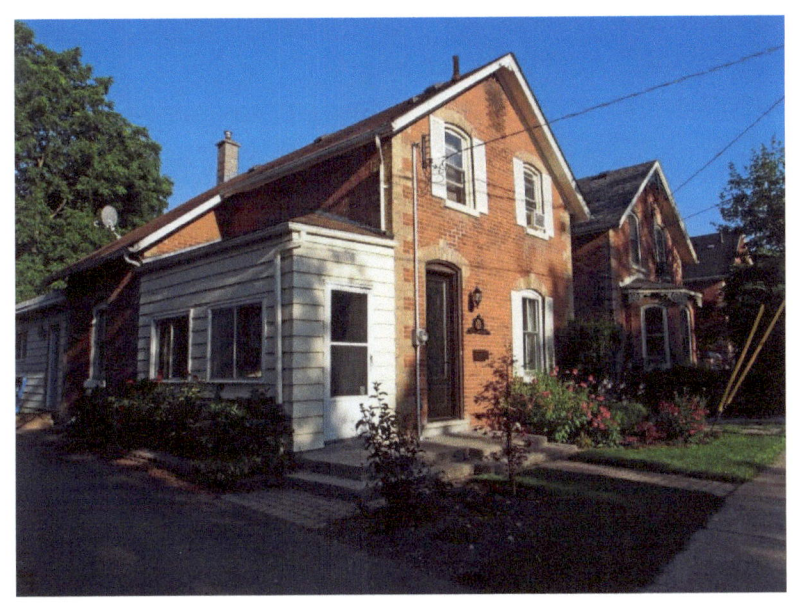

14 Bythia – Gothic – corner quoins

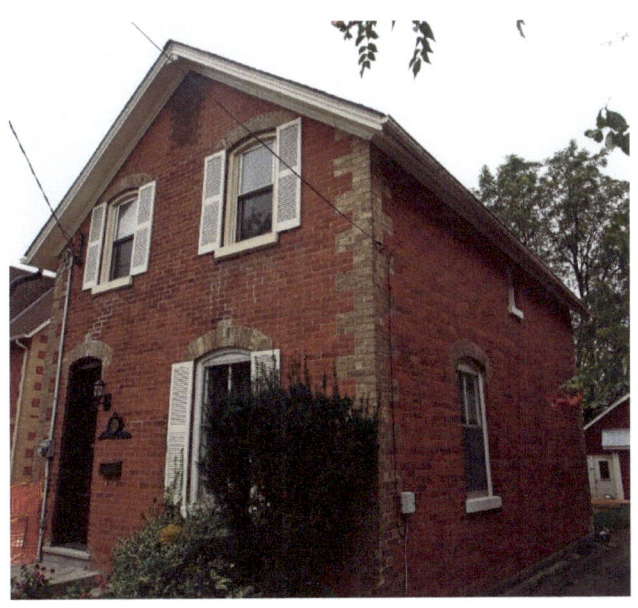

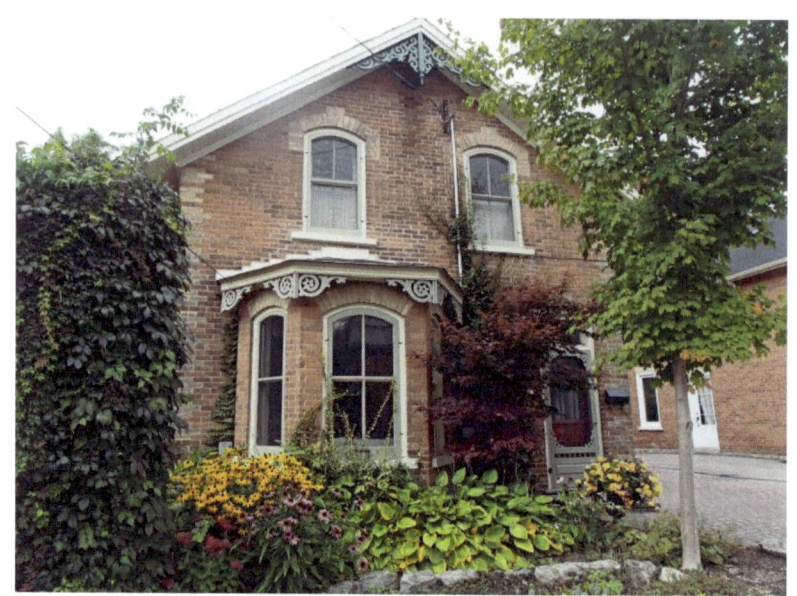
12 Bythia – Gothic Revival, window voussoirs and keystones

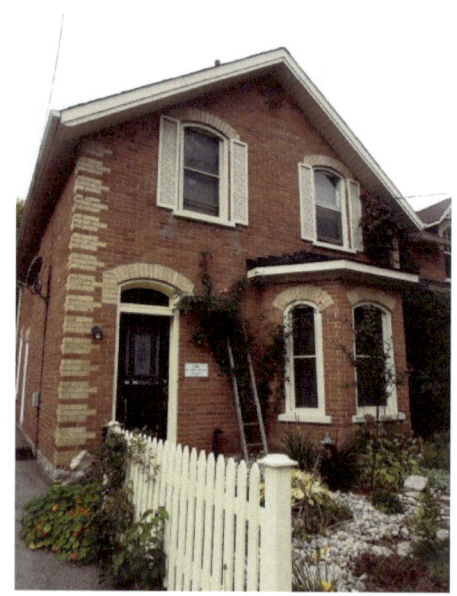
10 Bythia – Mary Jane Bennett, Seamstress c. 1885

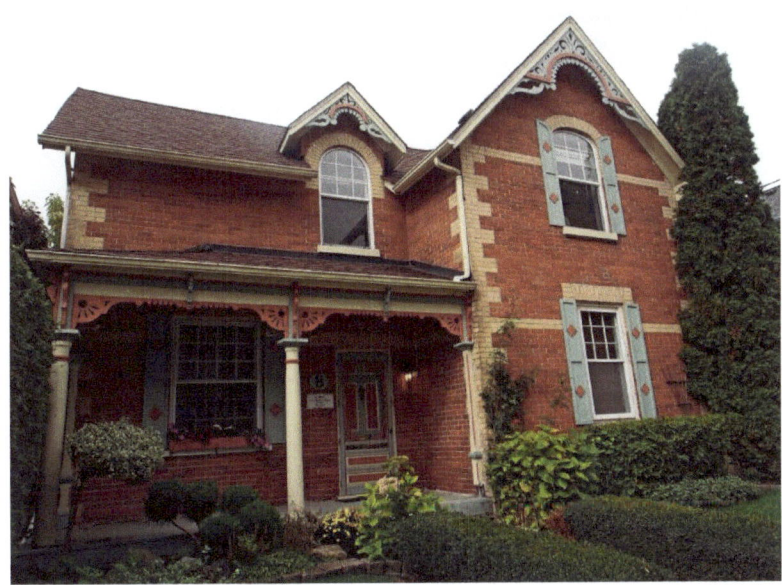

8 Bythia – John and Mary Ellen Haley, Merchant – c. 1891
Gothic Revival – decorative vergeboards on gables,
dichromatic brickwork, buff coloured voussoirs and lintels

6 Bythia – Italianate style – paired cornice brackets, dormer

4 Bythia Street – Italianate – single cornice brackets

Dormer in the attic

York Street

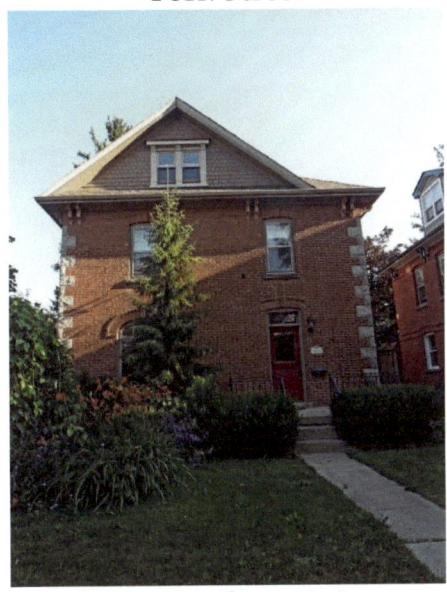

28 York Street – Italianate with quoining on corners, paired cornice brackets, and Gothic Revival sharply pitched gable

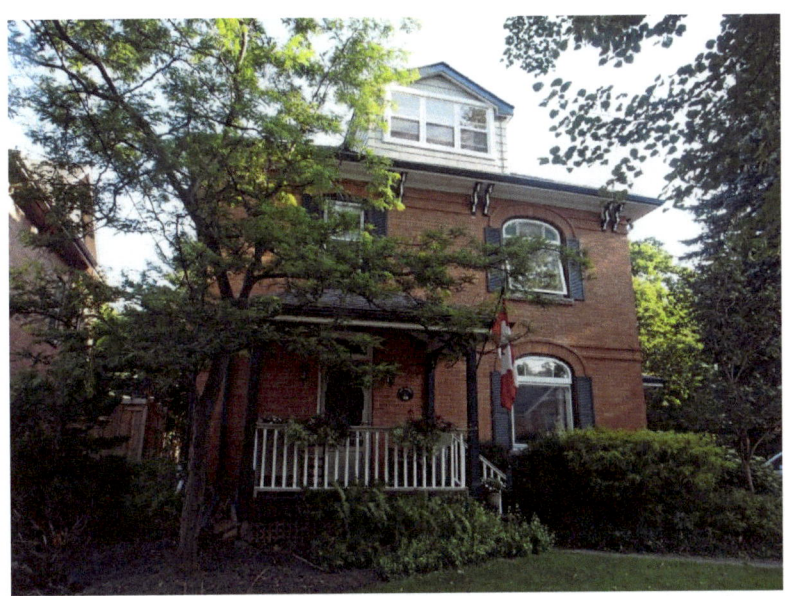

26 York Street – Italianate with paired cornice brackets, belvedere-like dormer

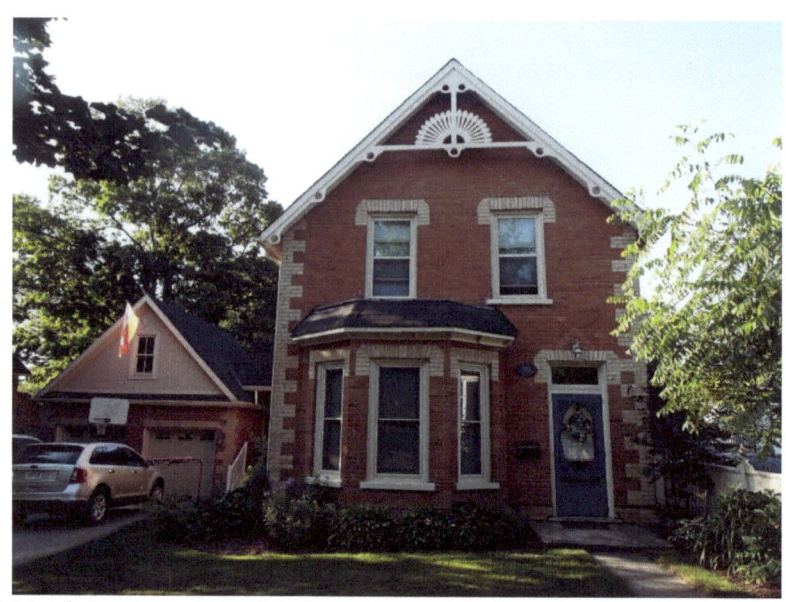

19 York Street – Gothic Revival with decorative Vergeboard on the sharply-pitched gable, bay window, buff-coloured voussoirs and corner quoins

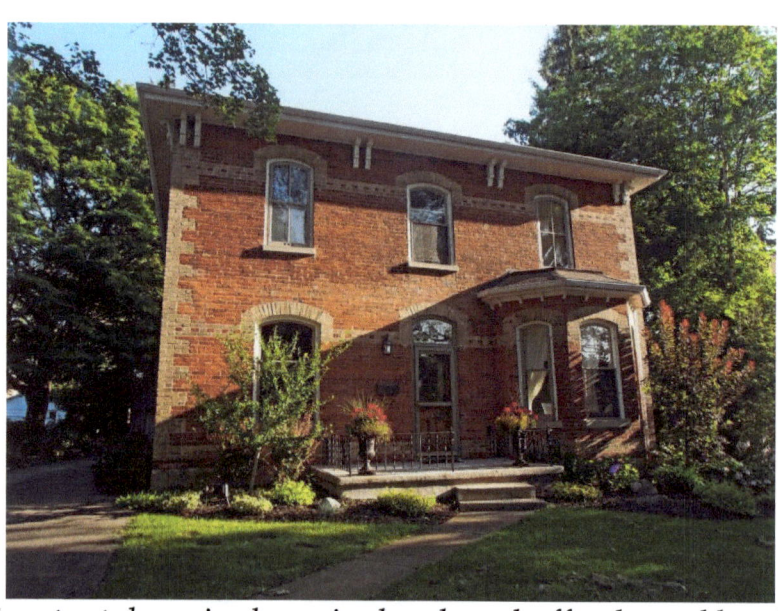

Italianate style, paired cornice brackets, buff-coloured banding and voussoirs, bay window

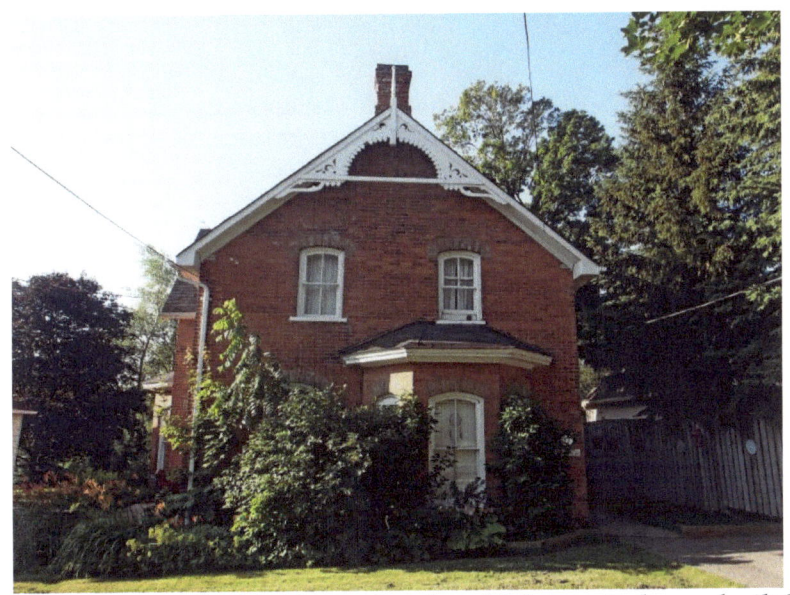

17 York Street – Gothic Revival style with bay window – built by tanner George Campbell who operated the tannery on Little York Street – c. 1880

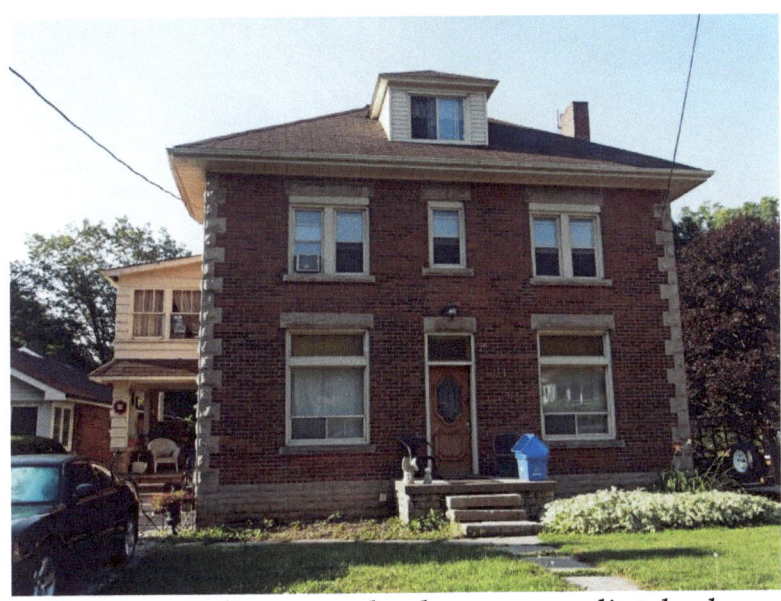

11 York Street – Italianate style - heavy stone lintels above and below the windows, and quoining on the corners, attic dormer

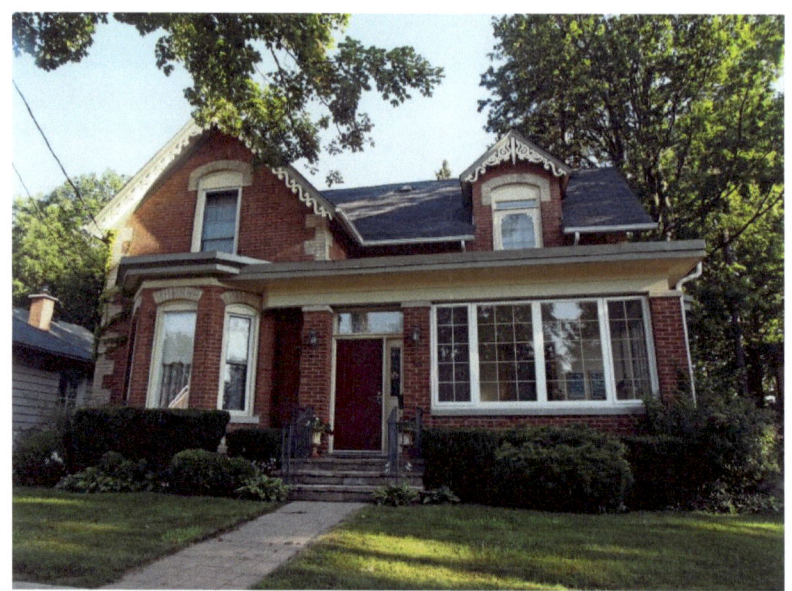

16 York Street – Gothic Revival – Robert McKeown, shoemaker – c. 1877 – steeply-pitched gable roofs, dichromatic brickwork and flat-arched window openings

14 York Street – multi-coloured brick – newer building

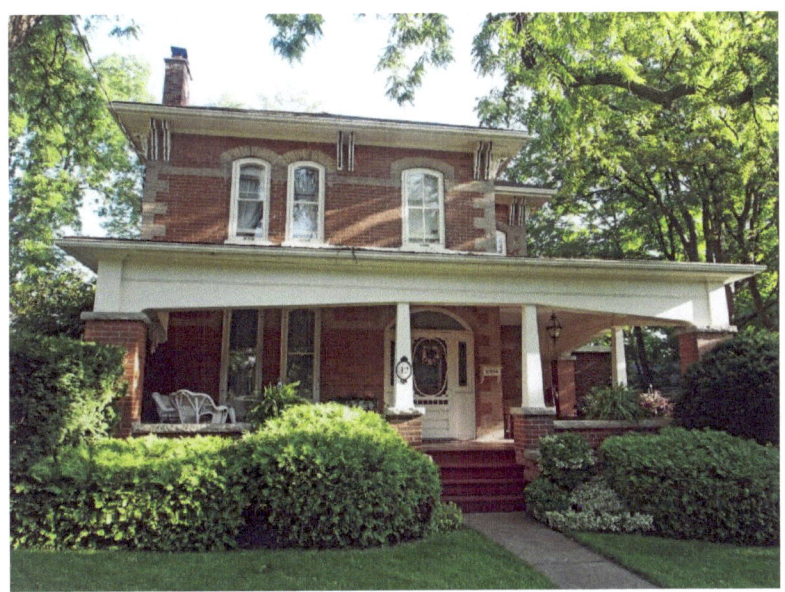

12 York Street built by John Rowan – Italianate style with hipped roof, dichromatic brickwork, paired cornice brackets – wraparound porch is a more recent addition

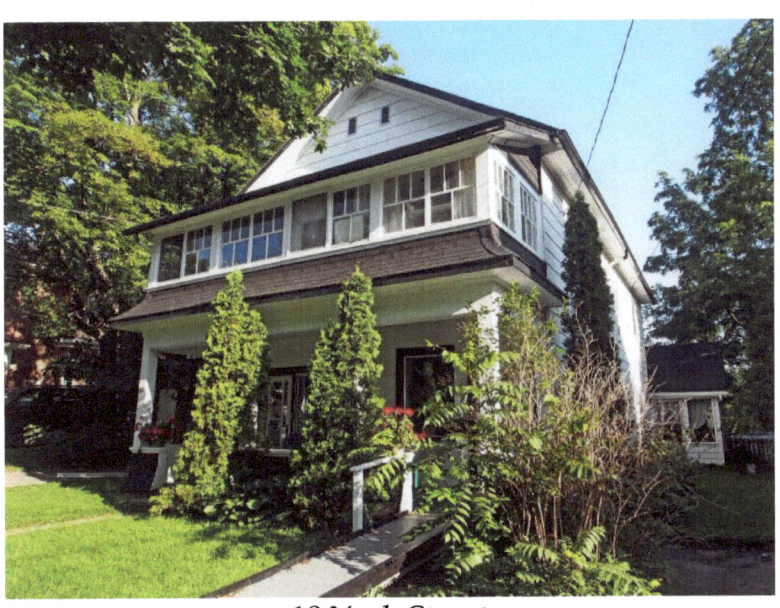

10 York Street

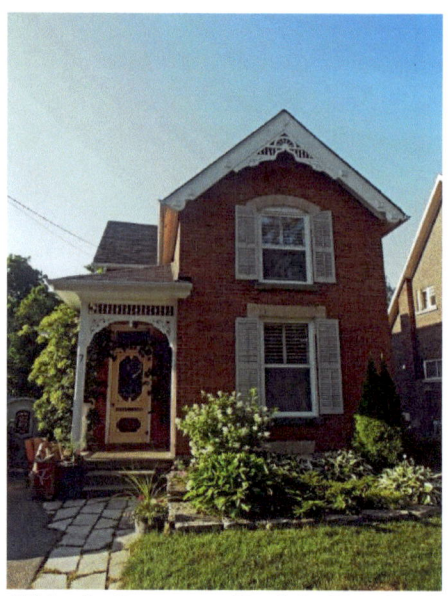

7 York Street – Gothic Revival

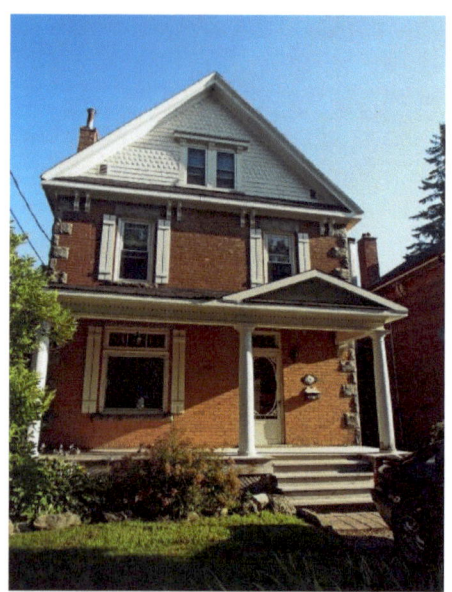

6 York Street – Edwardian style – corner quoins, paired cornice brackets, triangular pediment supported by columns

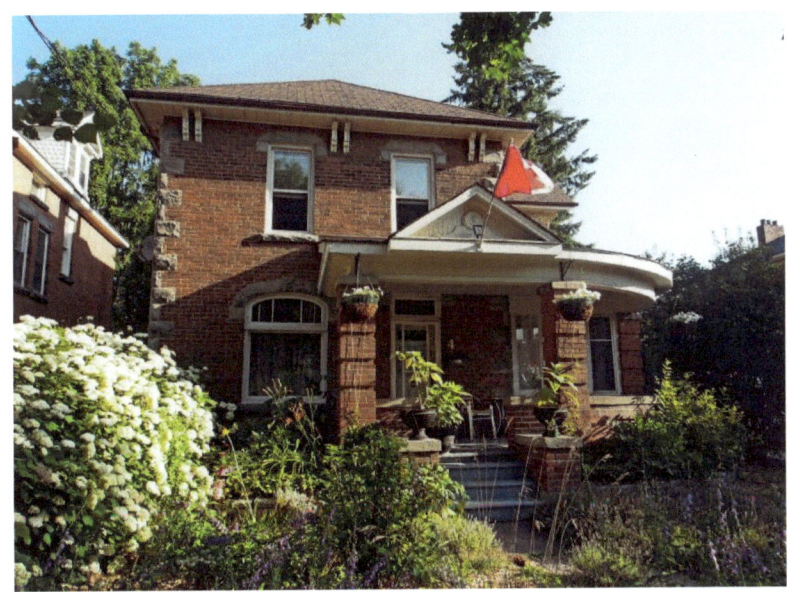

4 York Street – Italianate with triangular pediment with decorated tympanum, heavy stone voussoirs, paired cornice brackets

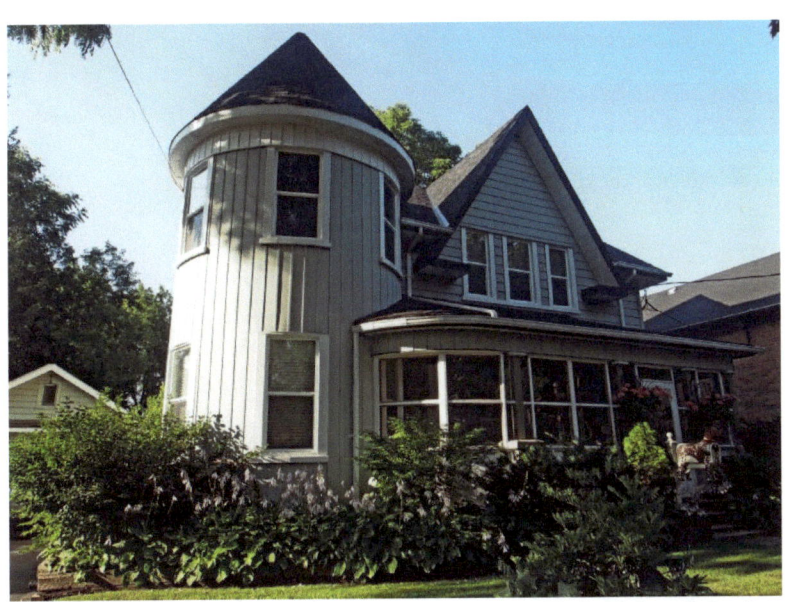

3 York Street – Vernacular Queen Anne– Primitive Methodist Chapel c. 1854 – turret added about 1911

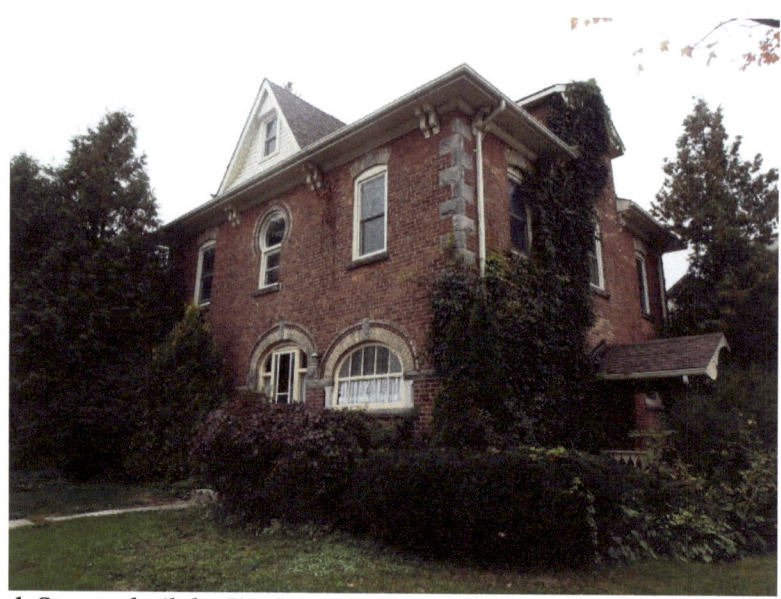

2 York Street – built by W. Connell – McBride House c. 1902 - Romanesque style with massive shape, east-facing tower (ivy covered), large arches over front window and door opening, unusual keyhole-shaped window. When Tweedsmuir Presbyterian Church was built to the north of this property, the McBride House became the manse for the Presbyterian minister.

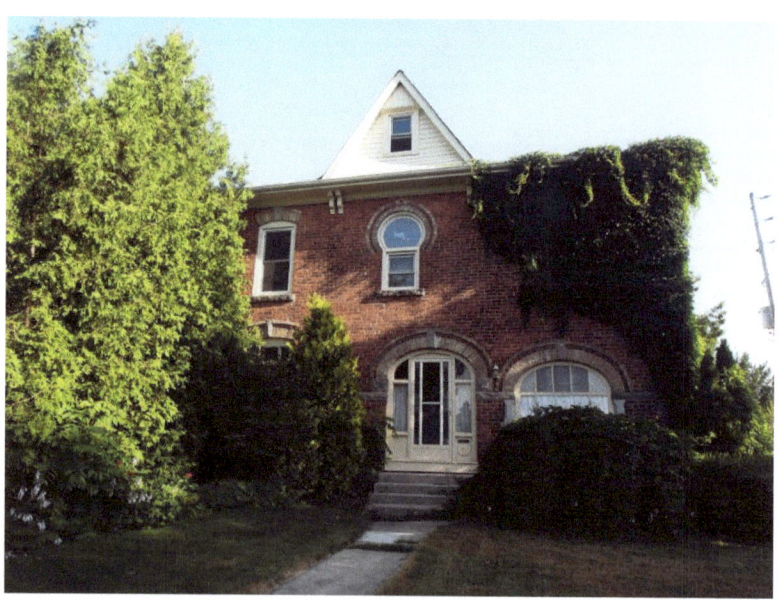

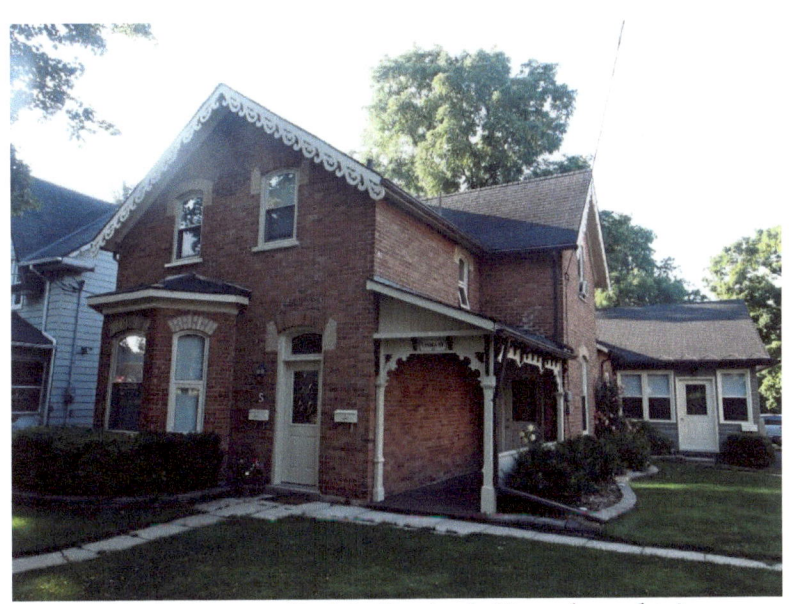

5 York Street – Gothic Revival, Vergeboard trim

Little York Street

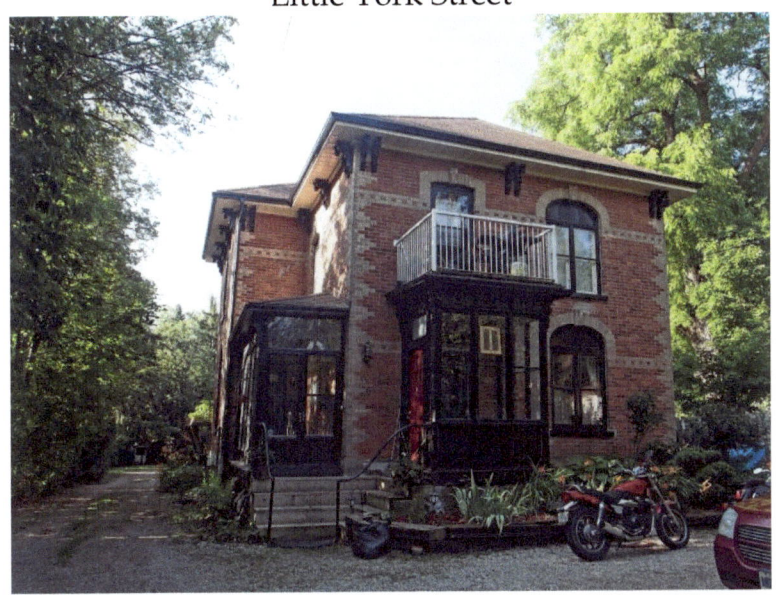

11 Little York Street – Italianate – buff-coloured brick banding and keystones and voussoirs, paired cornice brackets

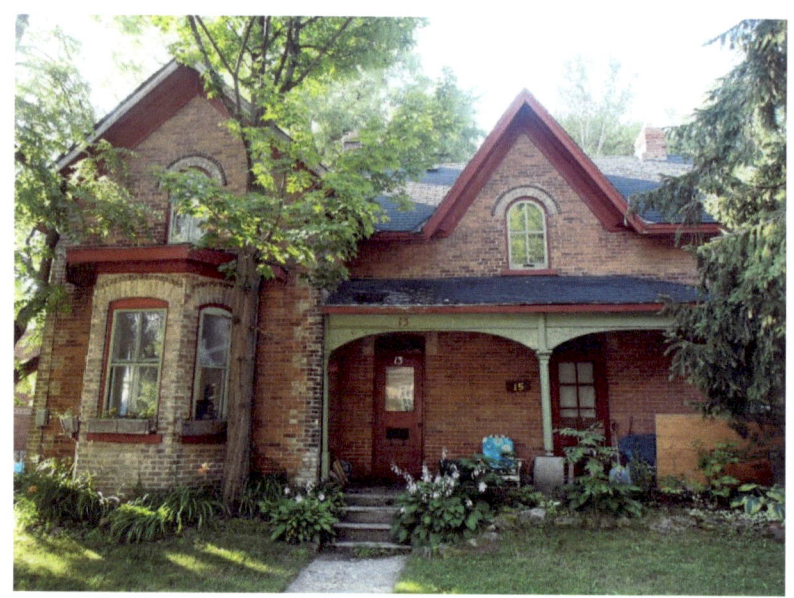

13-15 Little York Street – Gothic Revival style

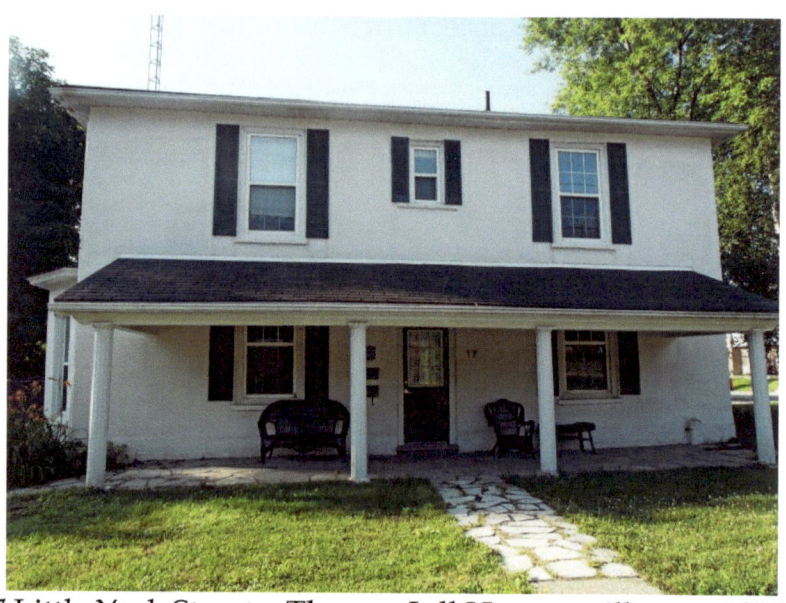

17 Little York Street – Thomas Jull House, miller – c. 1858 – Regency style with hip roof, large windows and bay windows on the sides, originally clad in red brick and had a trellis verandah (stuccoed later)

John Street

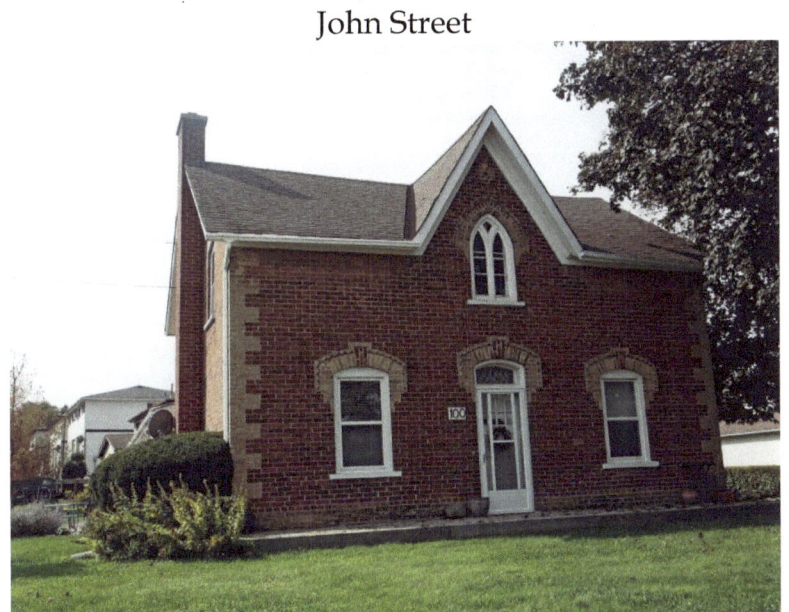

100 John Street – lancet window, buff-coloured voussoirs, dichromatic brickwork

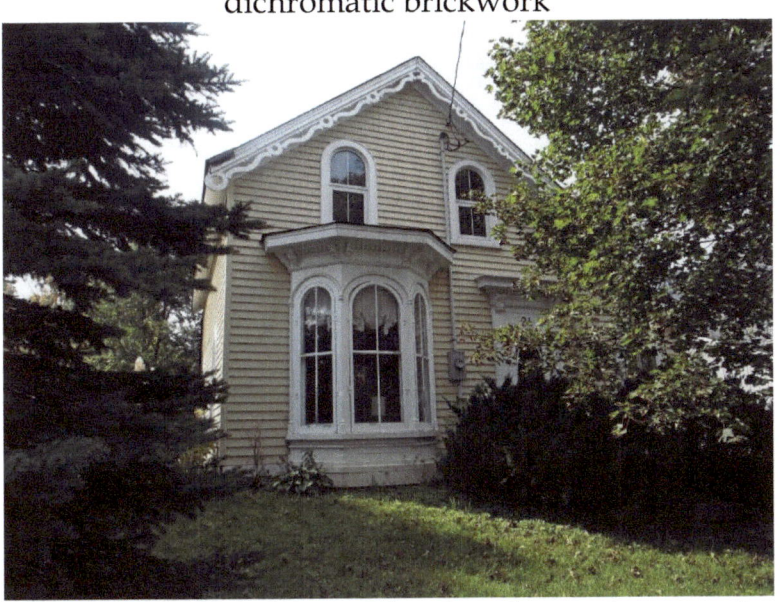

24 John Street – Gothic Revival style – decorative vergeboard on sharply pitched gable, bay window with paired cornice brackets

8 John Street – Lawrence House c. 1850 – built for Orange and Sarah Lawrence – Georgian style – 1½ storeys, large window openings, return eaves in the gable ends of the roof – underneath the siding is a stucco exterior over log

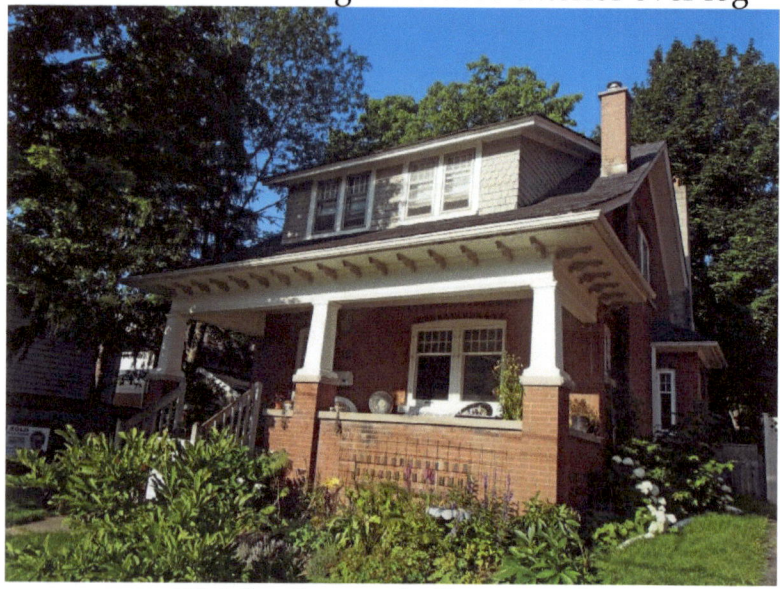

12 John Street - Italianate style

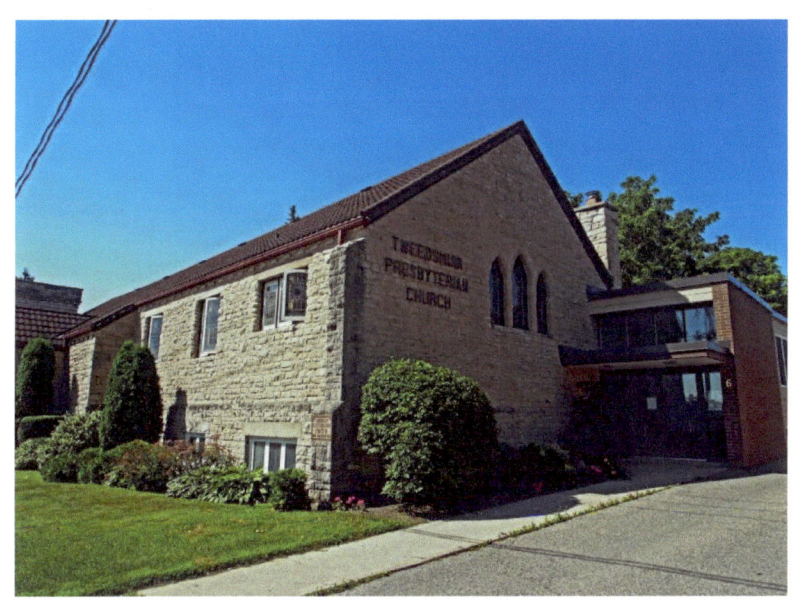

6 John Street – Tweedsmuir Memorial Presbyterian Church
1837, 1940 and 1959

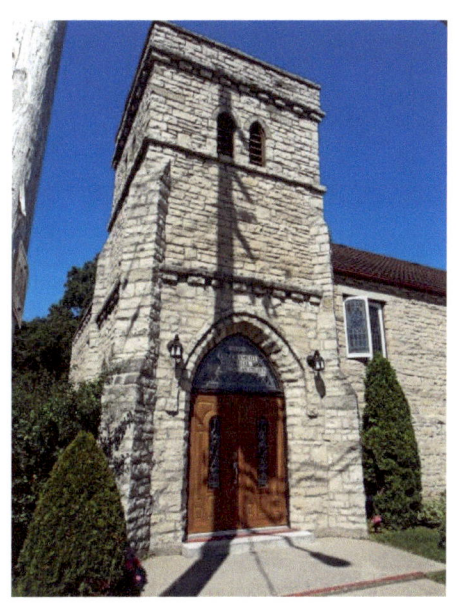

Mill Street

51 Mill Street – Italianate style, paired cornice brackets, buff coloured banding, heavy stone voussoirs

53 Mill Street – Italianate style – dichromatic brickwork

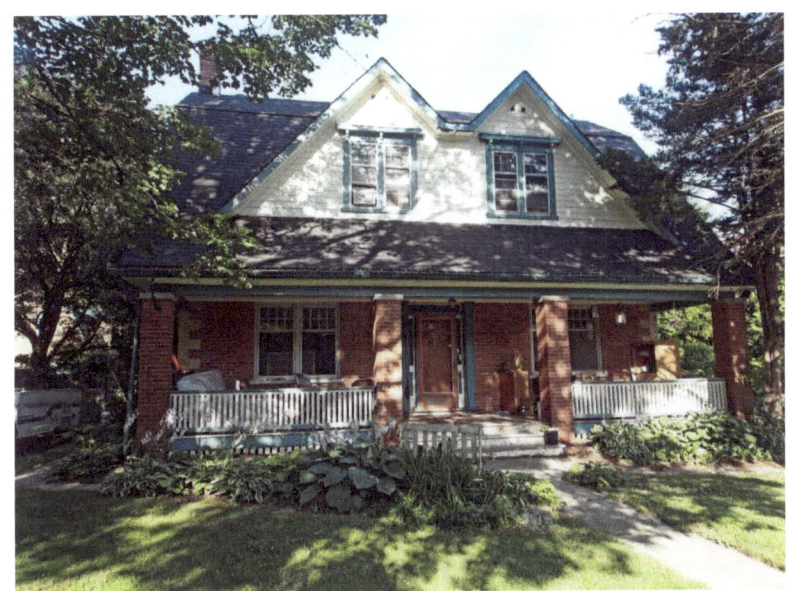

56 Mill Street – Gothic Revival

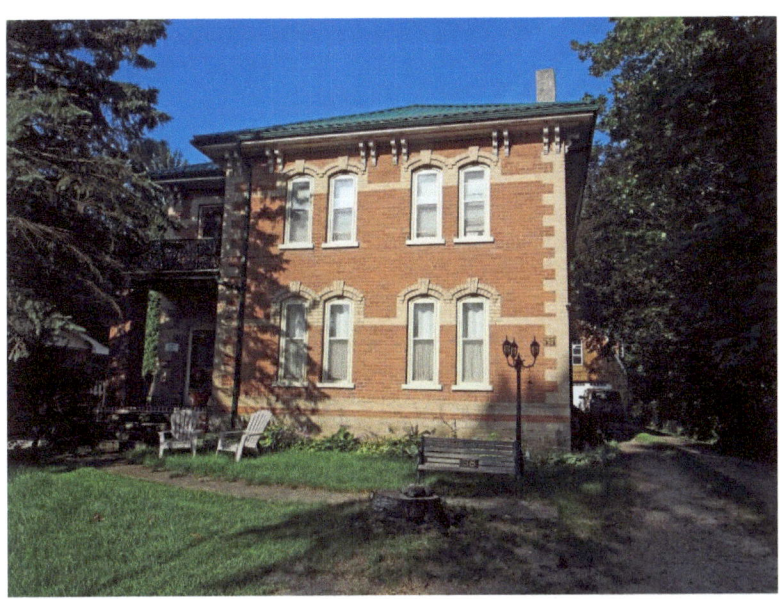

58 Mill Street – Italianate, buff coloured banding, keystones and voussoirs, dichromatic brickwork on corners, paired cornice brackets – Joseph Foster, Contractor c. 1888

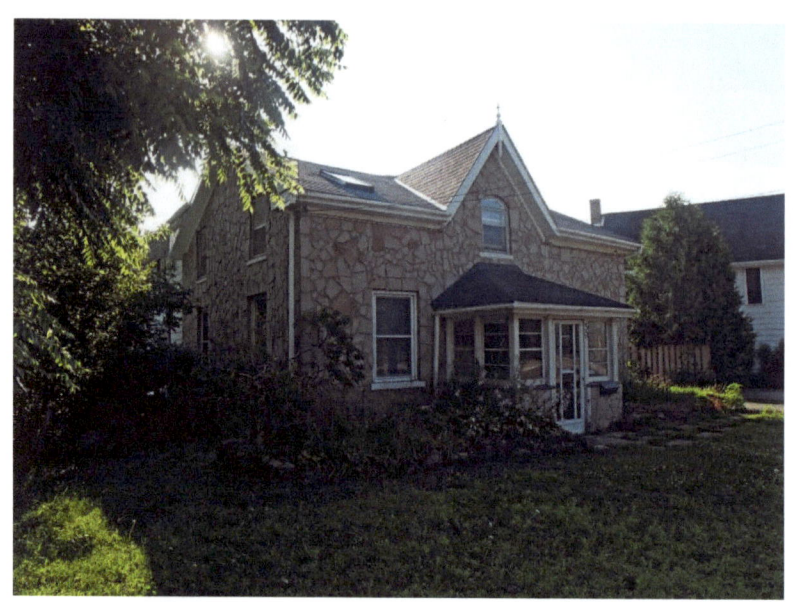

59 Mill Street – cobblestone – Gothic Cottage

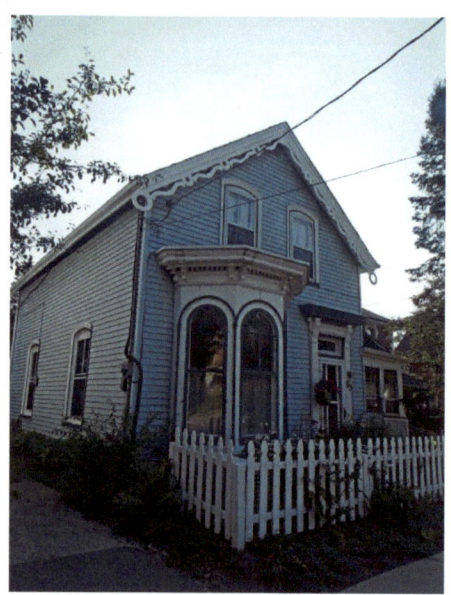

63 Mill Street – Gothic Revival – decorative vergeboard

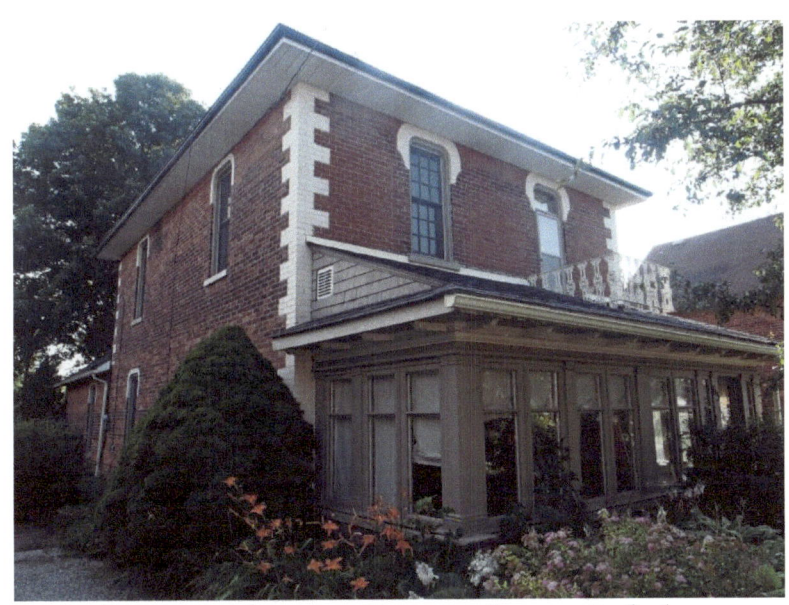
Italianate with second-storey door onto balcony

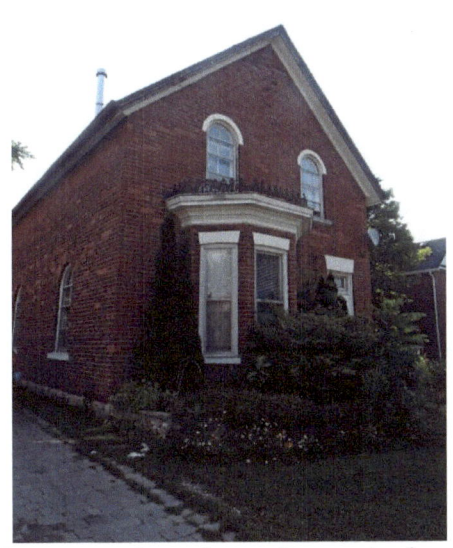
Iron cresting above bay window

68 Mill Street - cottage

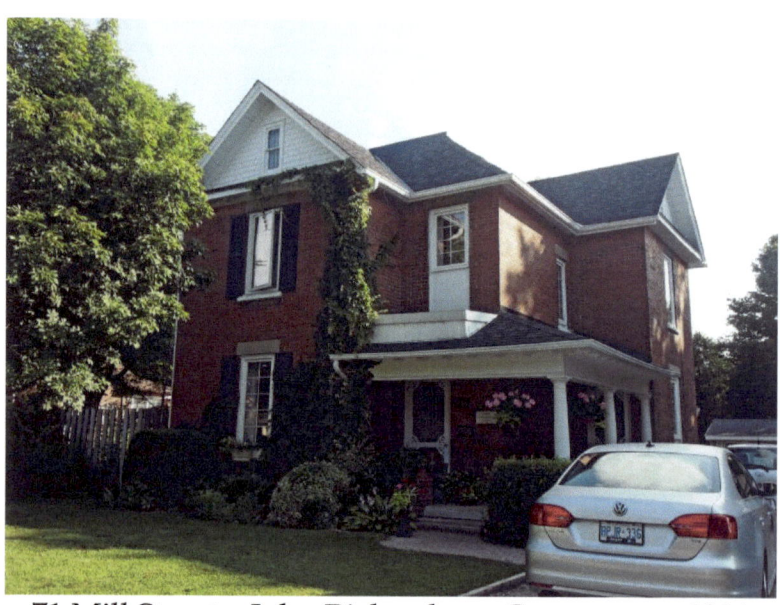

71 Mill Street – John Richardson, Carpenter c. 1904

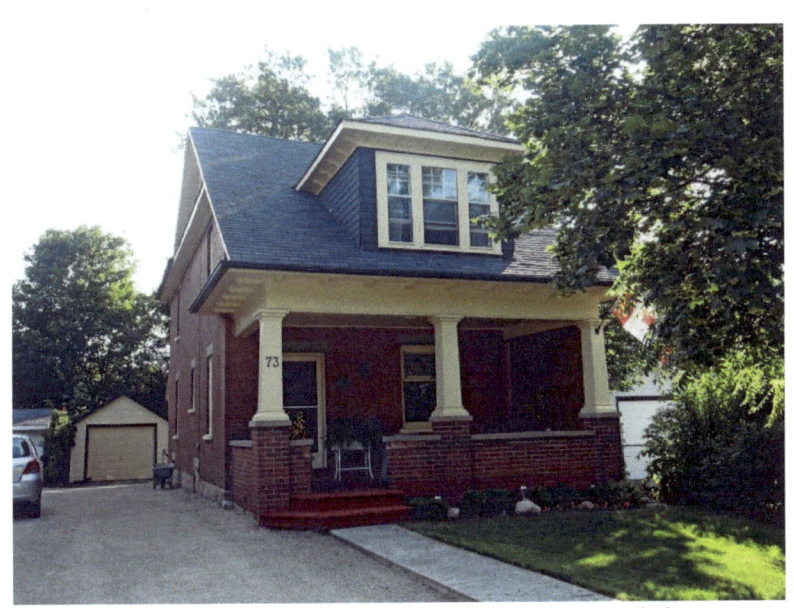

73 Mill Street – dormer above verandah

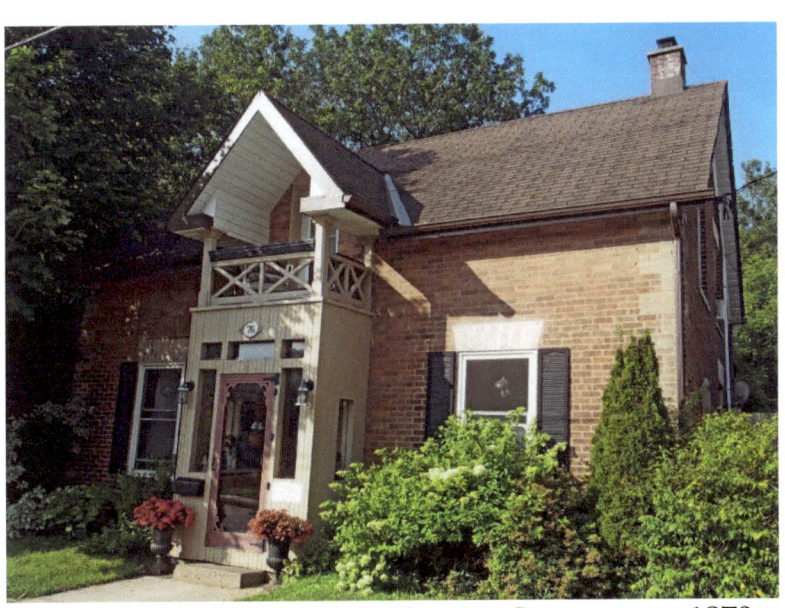

76 Mill Street – Joseph S. Hewitt, Carpenter c. 1870

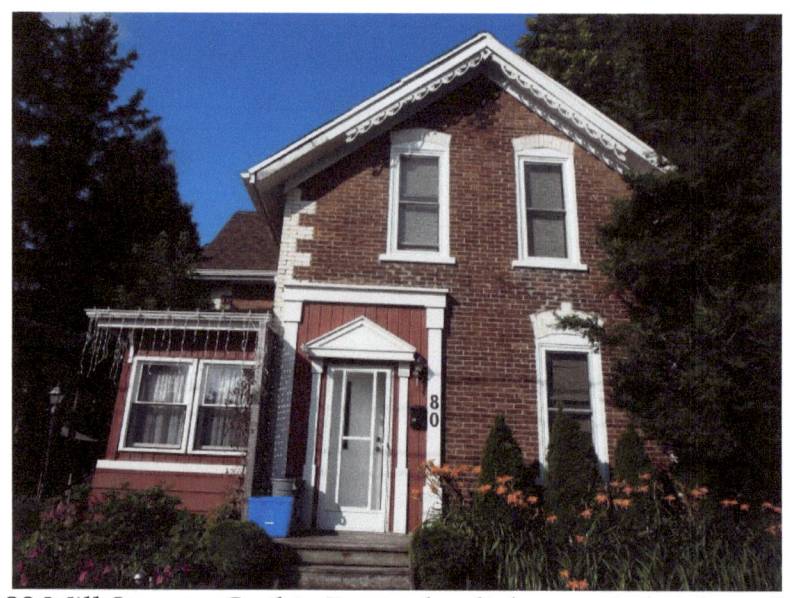
80 Mill Street – Gothic Revival – dichromatic brickwork

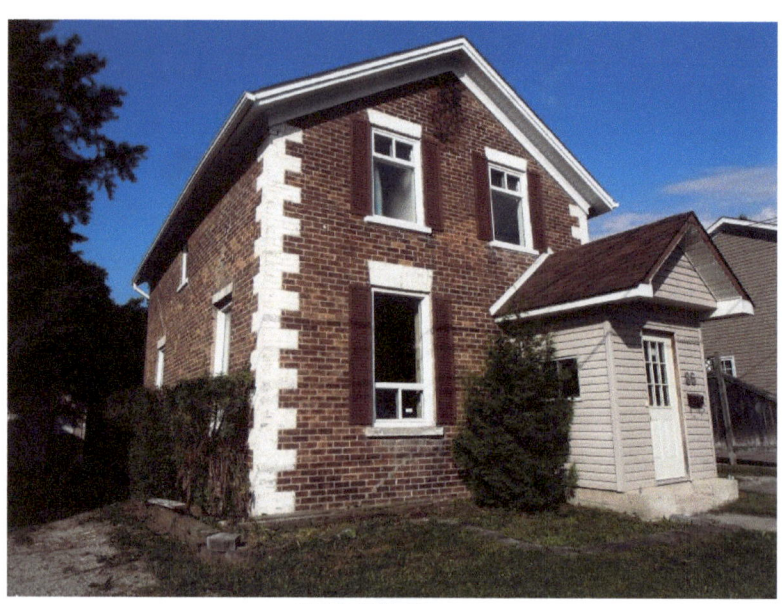
86 Mill Street

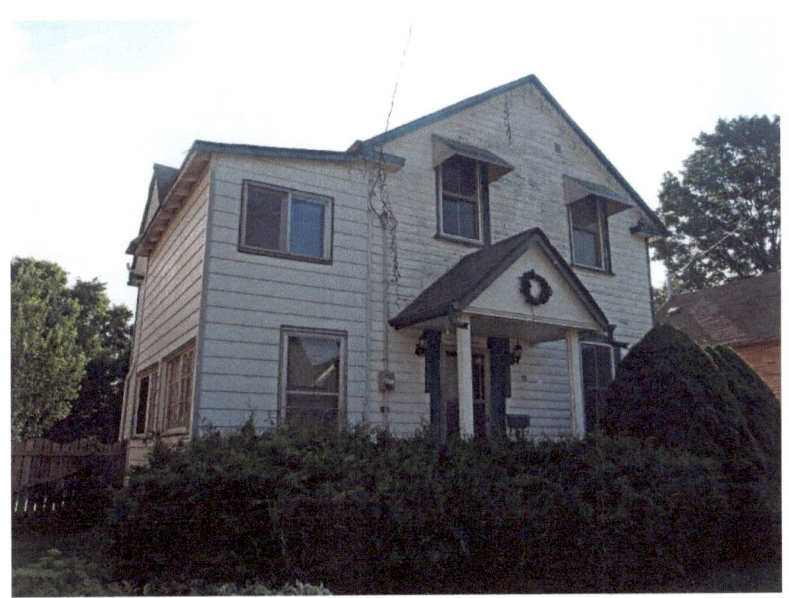

91 Mill Street

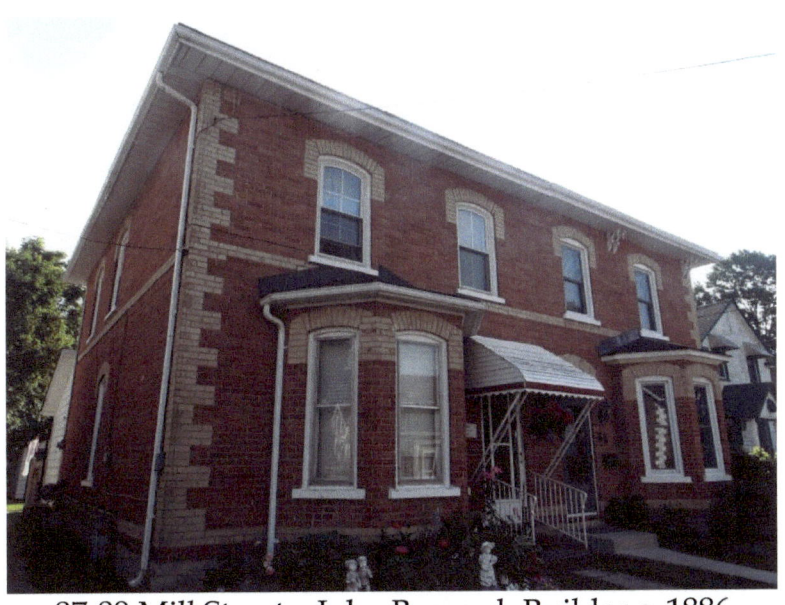

87-89 Mill Street – John Bernard, Builder c. 1886
Dichromatic brickwork

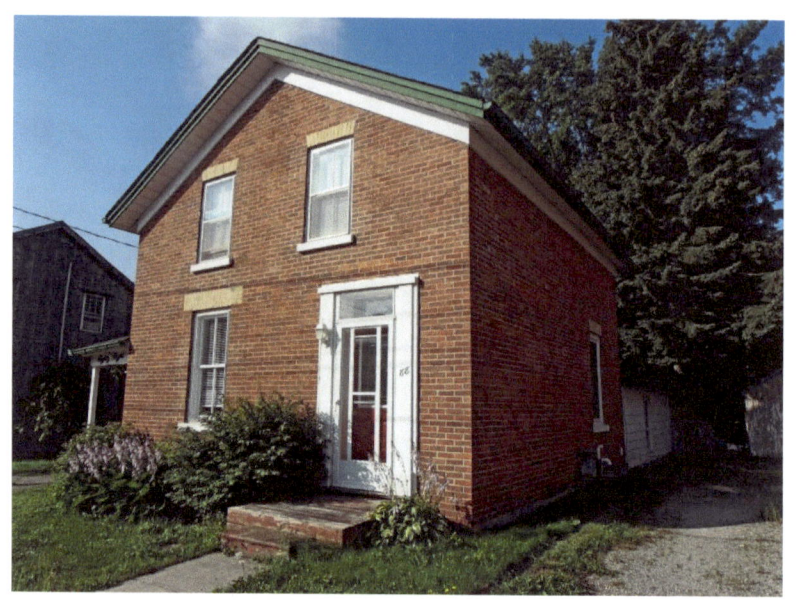

88 Mill Street

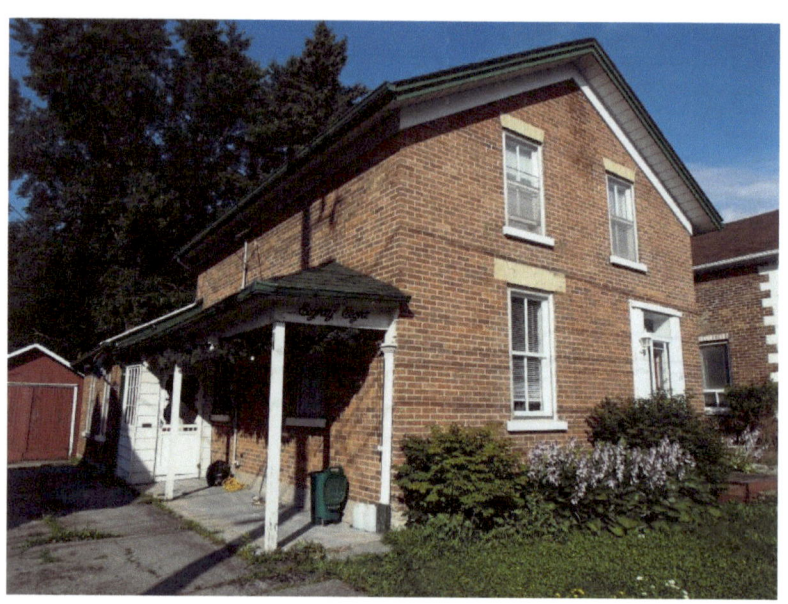

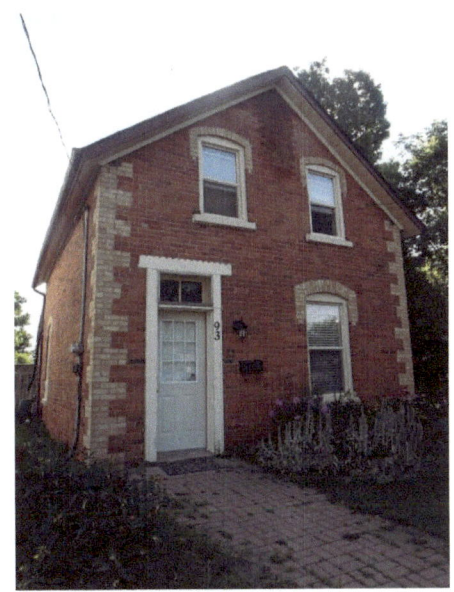

64 Mill Street

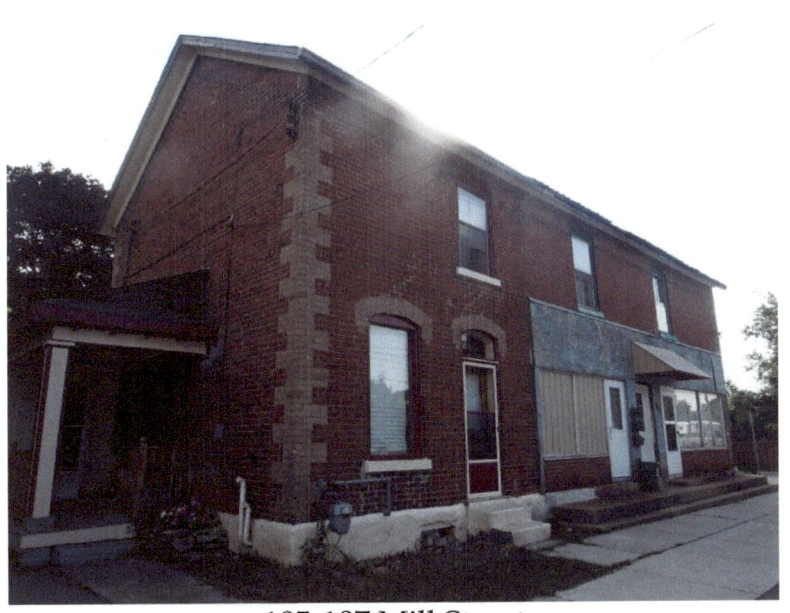

105-107 Mill Street

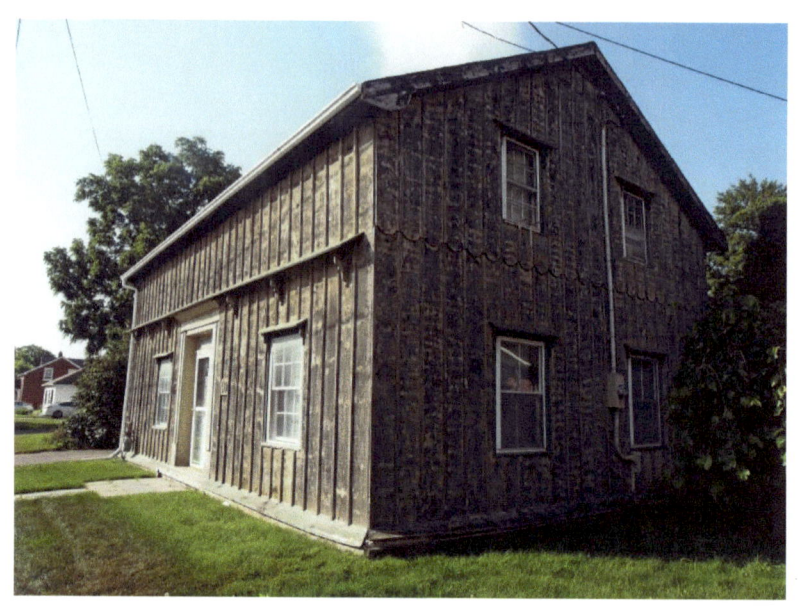

90 Mill Street – Ryan Hotel, Peavoy House c. 1873

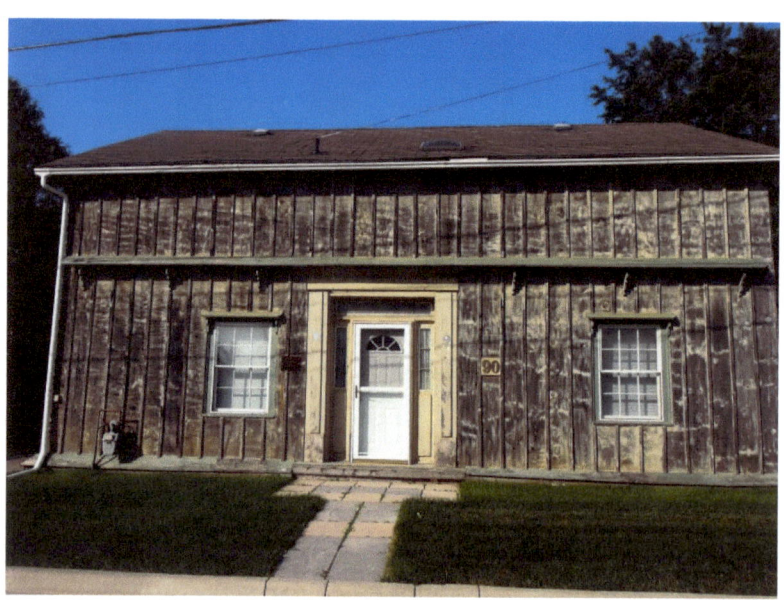

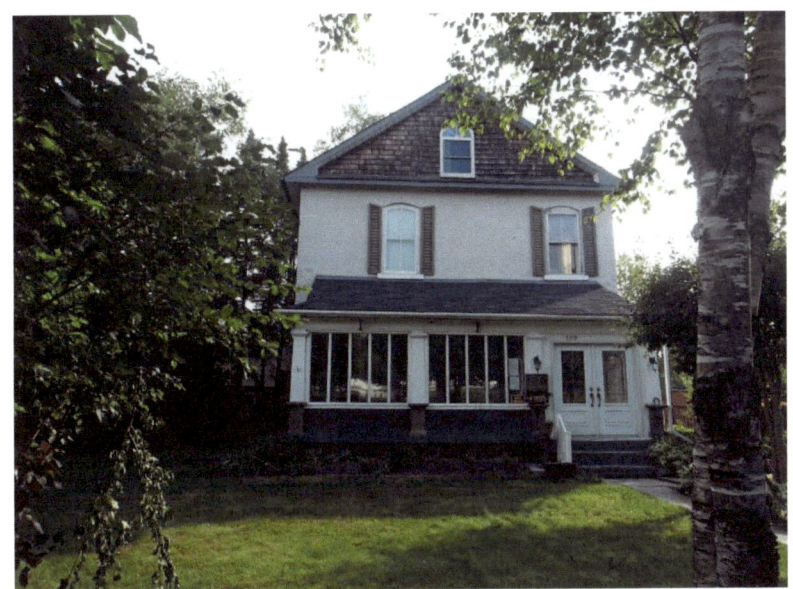

109 Mill Street

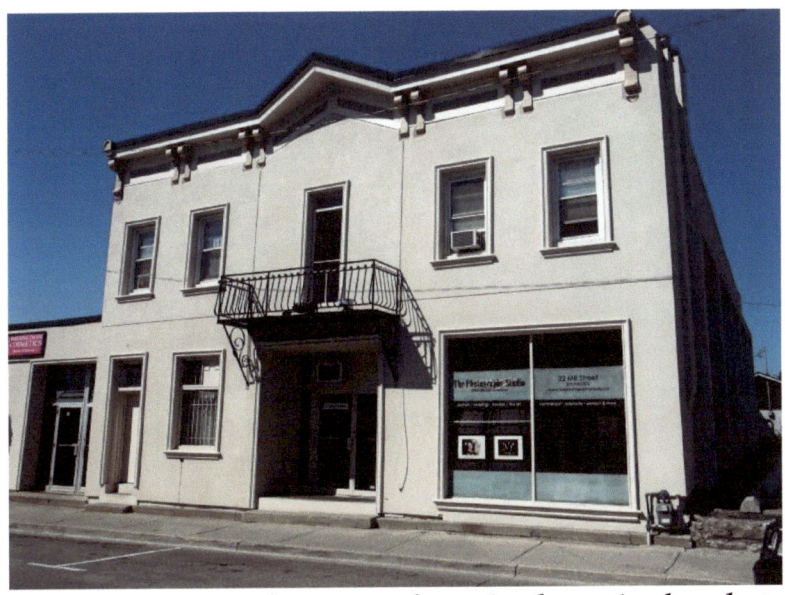

22 Mill Street – Italianate style, paired cornice brackets

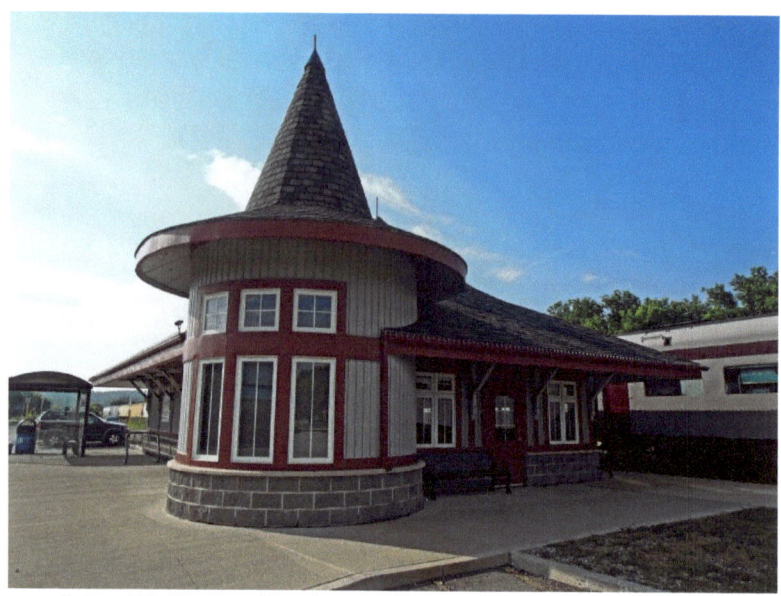

Town Line Railway Station – the rail line connects the town with the CN main line in Brampton and the CP mainline in Streetsville

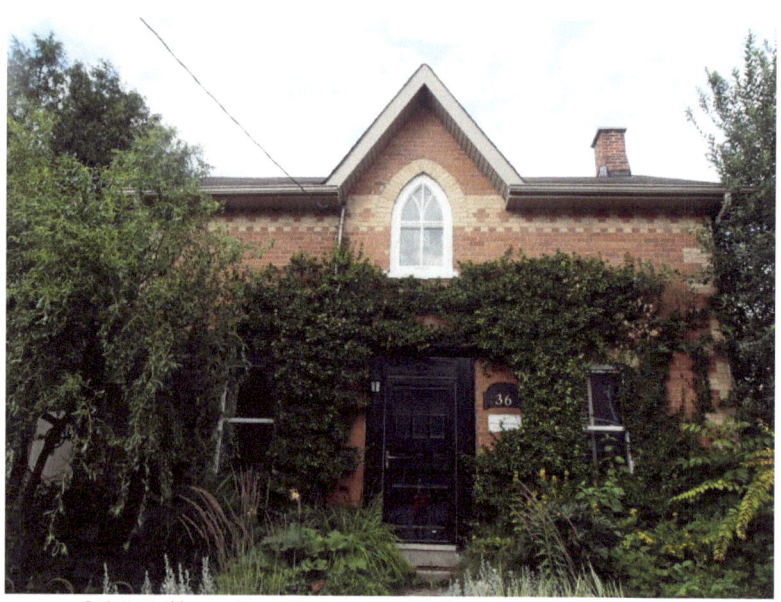

36 Wellington Street – dichromatic banding

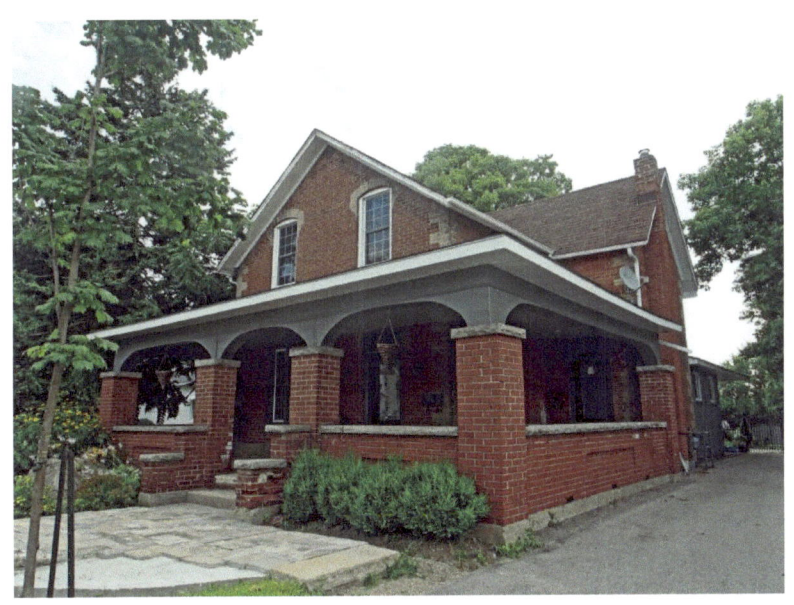

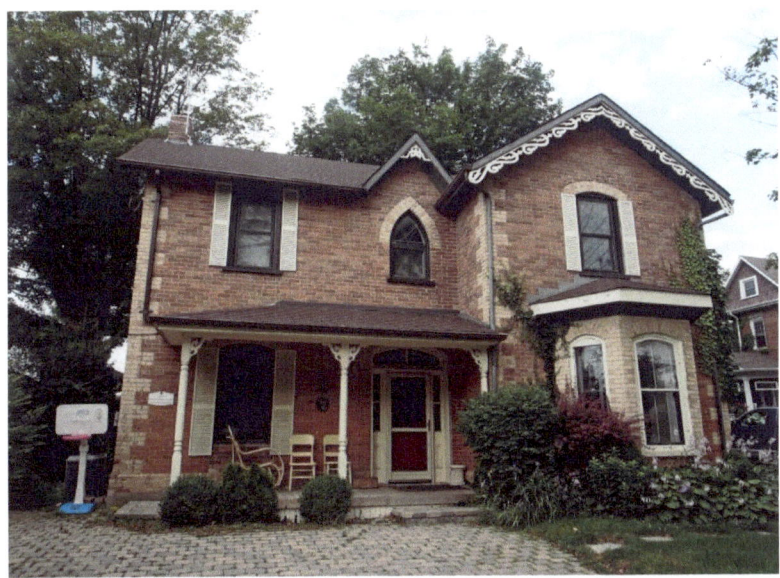

30 Wellington Street – Christina and Frederick Marshall, Saddler and Harness Maker c. 1877 – Gothic Revival

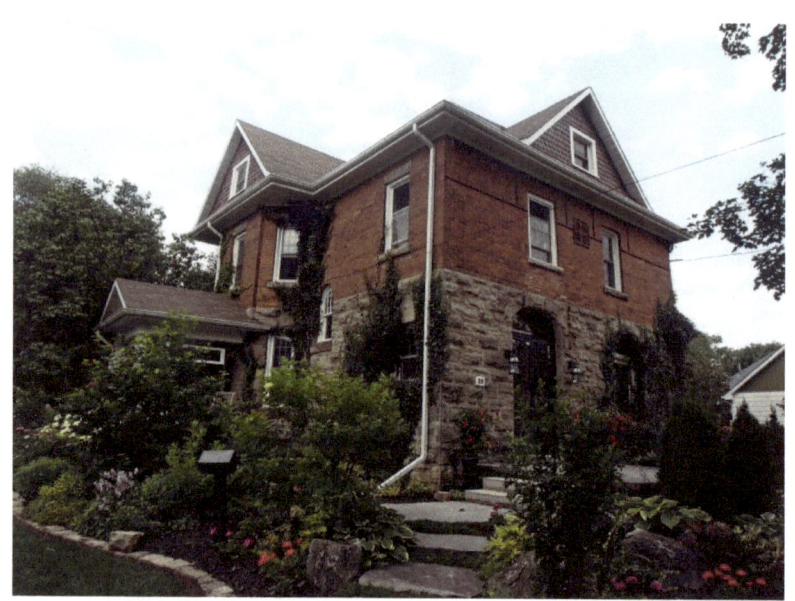

28 Wellington Street

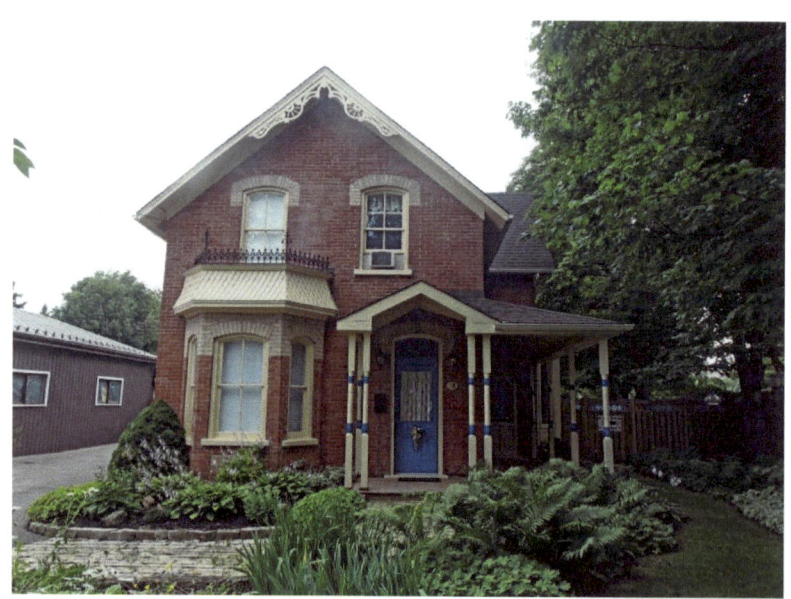

31 Wellington Street – iron crest work above bay window, decorative Vergeboard in steeply pitched gable
Gothic Revival

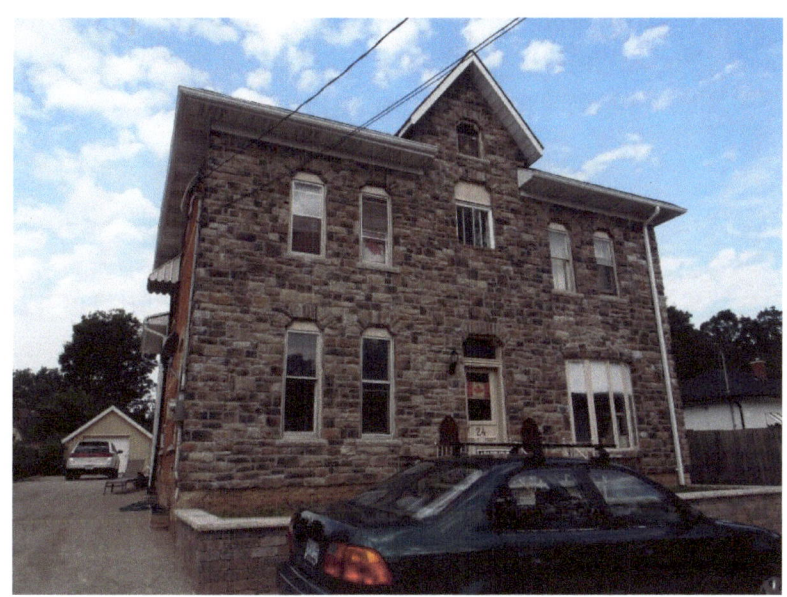

24 Wellington Street

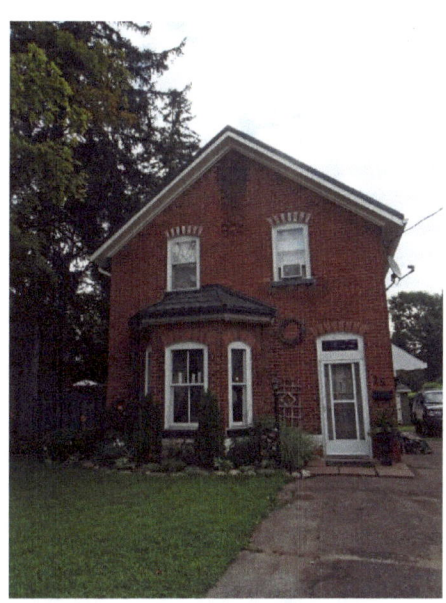

25 Wellington Street – Gothic Revival

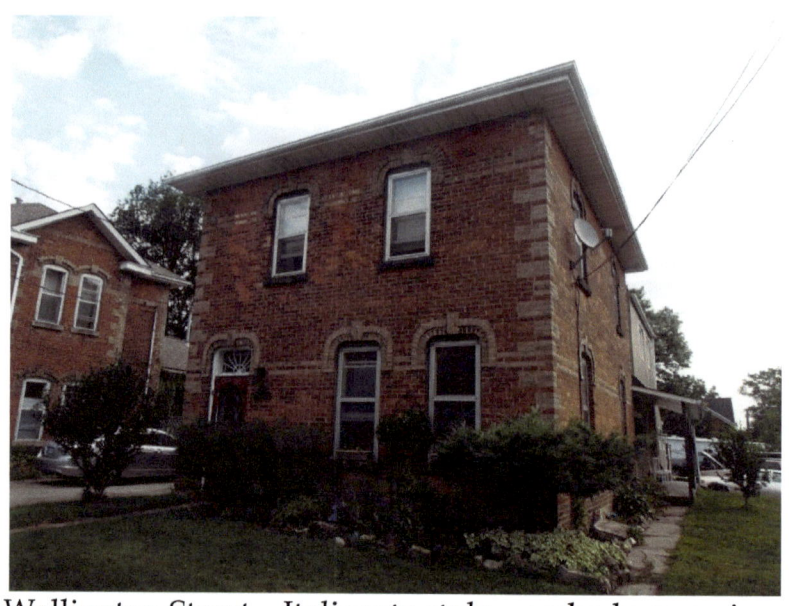

21 Wellington Street – Italianate style – arched voussoirs and keystones, wide eaves formerly with cornice brackets, dichromatic brickwork

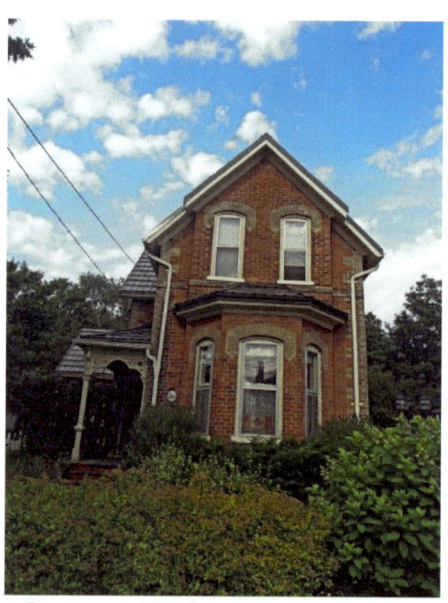

20 Wellington Street – Gothic Revival, corner quoins, bay window

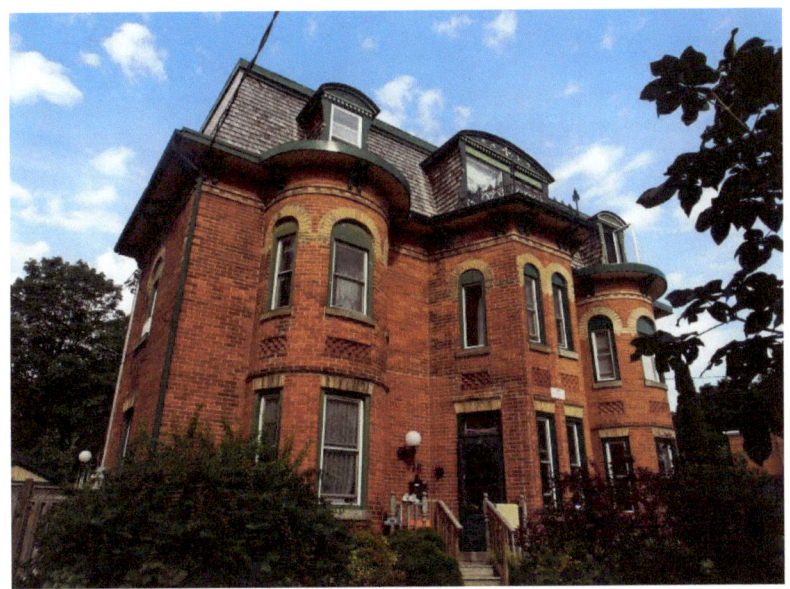

16-18 Wellington Street – King House c. 1888 - Second Empire style – large brick house, mansard roof, ornamental ironwork

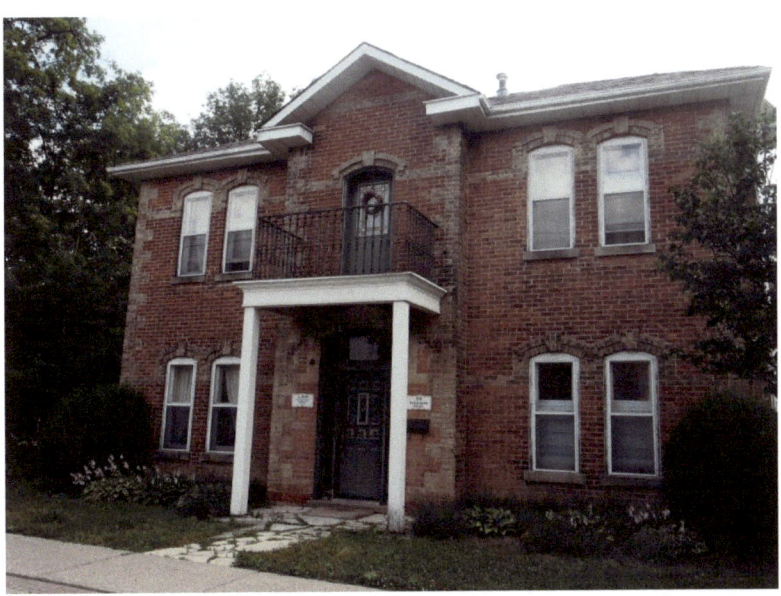

19 Wellington Street – Italianate with two-storey frontispiece and second floor balcony

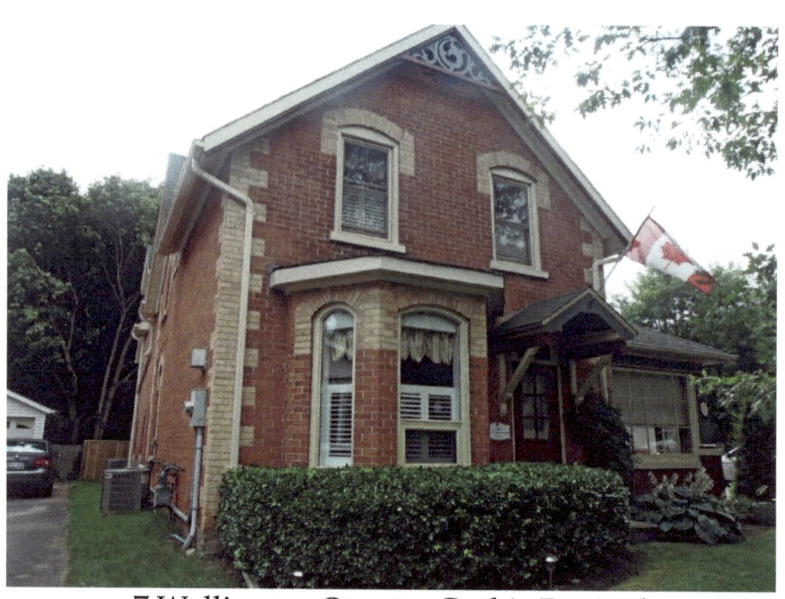

7 Wellington Street – Gothic Revival
Edward and Adelaide Armstrong, Builder c. 1887

10 Wellington Street – Andrew and Margaret Mara,
Shoemaker c. 1852

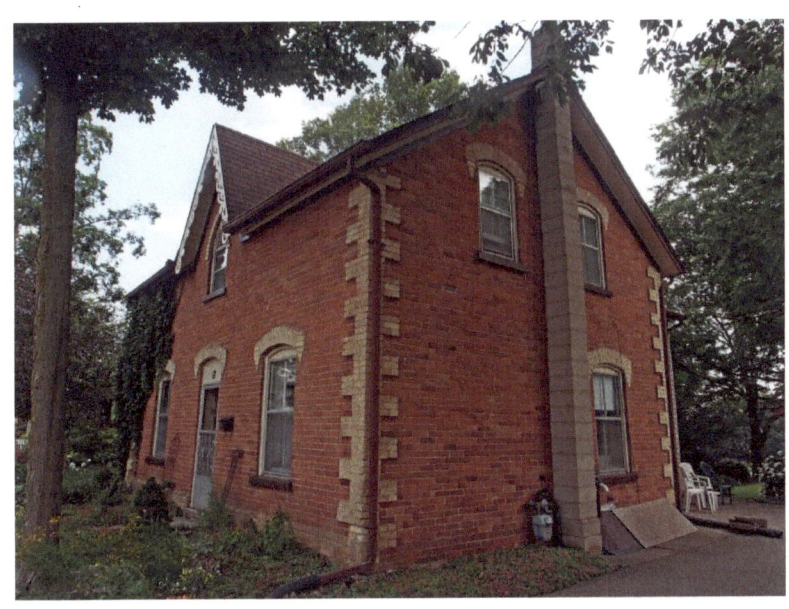

17 Wellington Street – Gothic Revival, corner quoins,
Vergeboard trim on gable

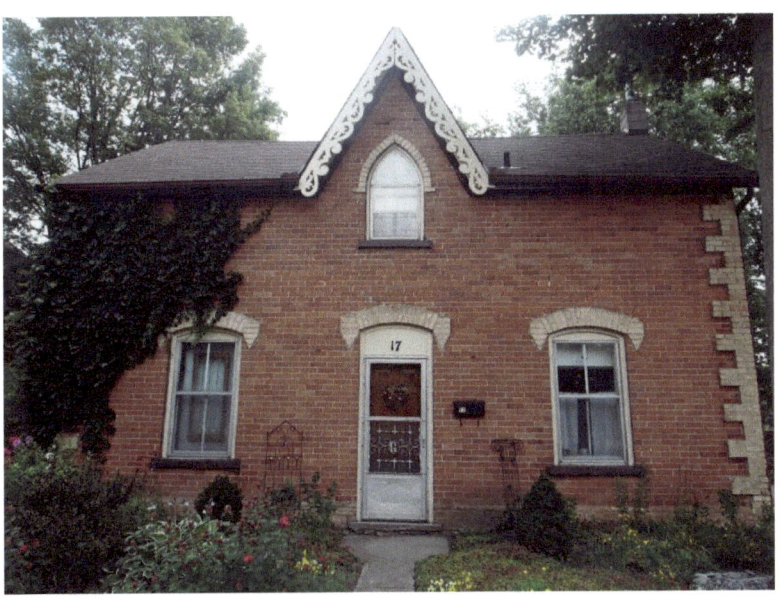

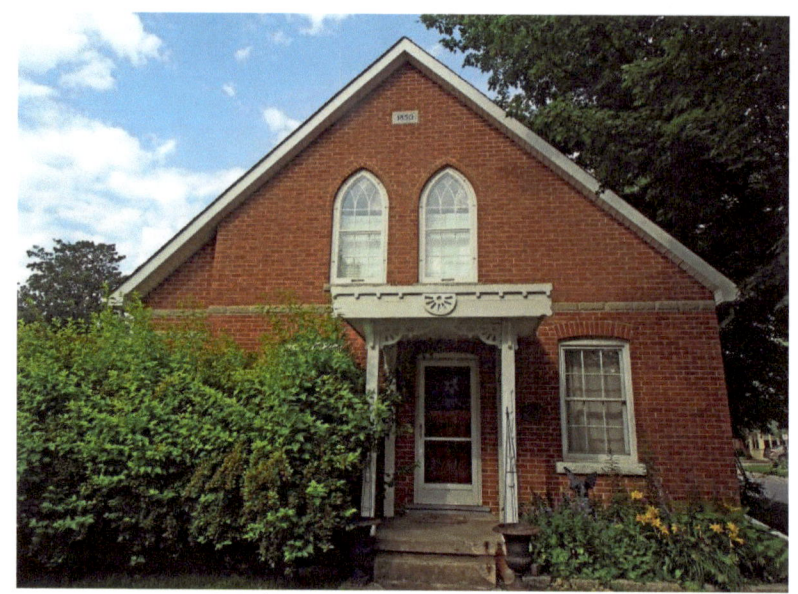

Wellington Street – c. 1850

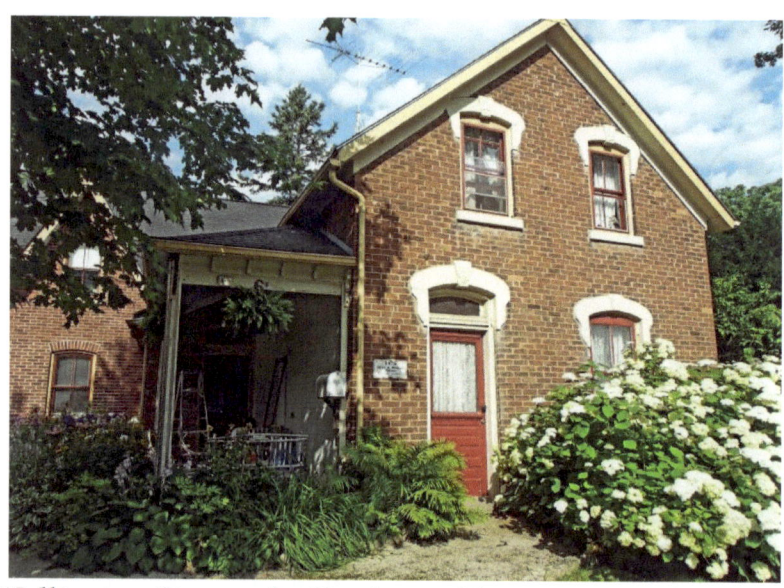

6 Wellington Street – buff-coloured keystones and voussoirs
Eliza and William Sutton, Stone Cutter c. 1876

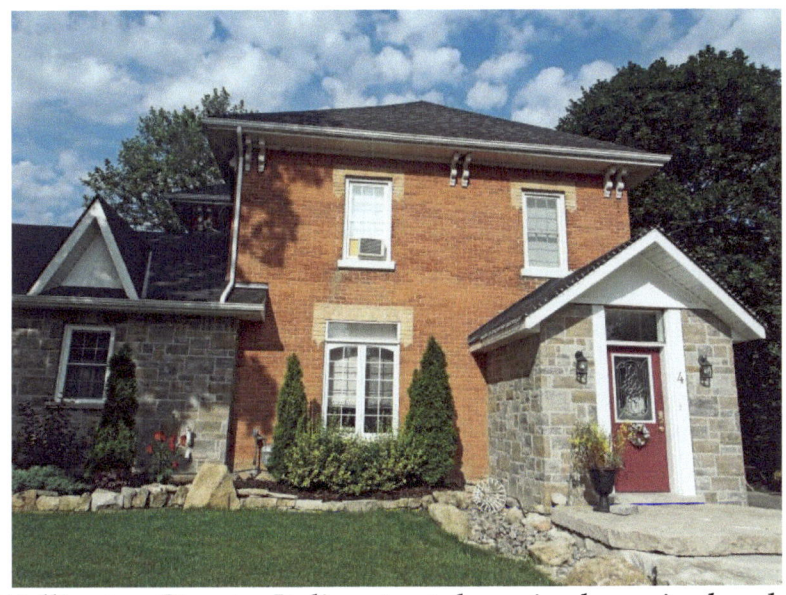

4 Wellington Street – Italianate style, paired cornice brackets

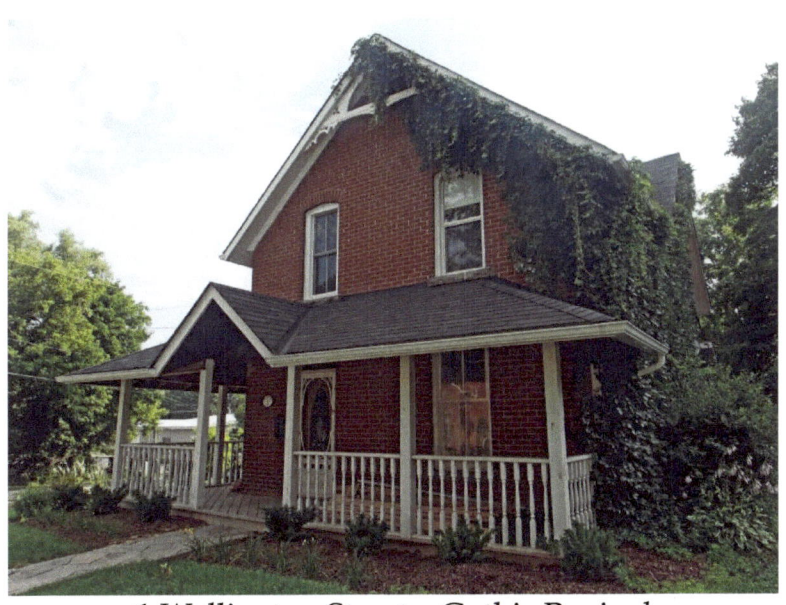

1 Wellington Street – Gothic Revival

2 Wellington Street – Armstrong Foundry c. 1896

Church Street

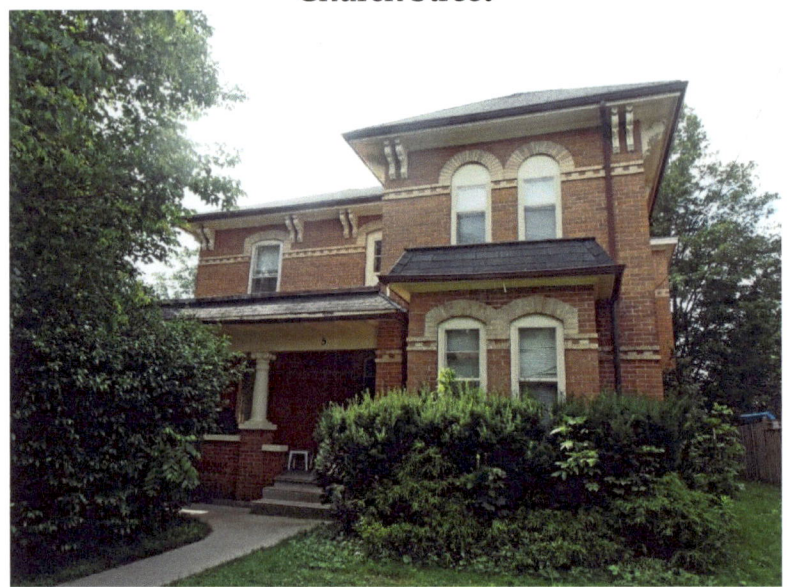

5 Church Street – Italianate, arched window voussoirs, paired cornice brackets, dichromatic banding

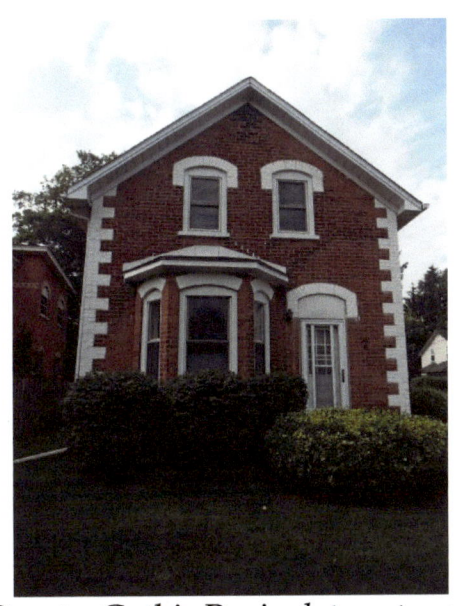

7 Church Street – Gothic Revival, two-tone brickwork

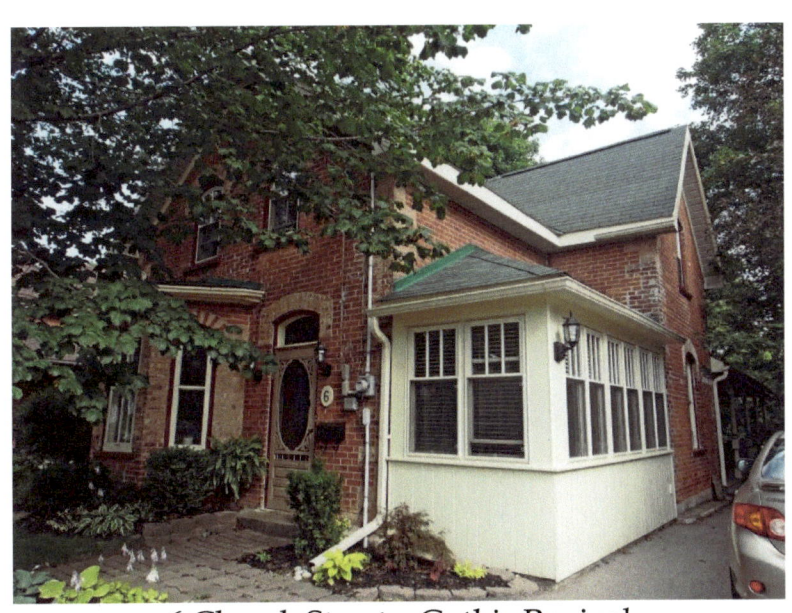

6 Church Street – Gothic Revival

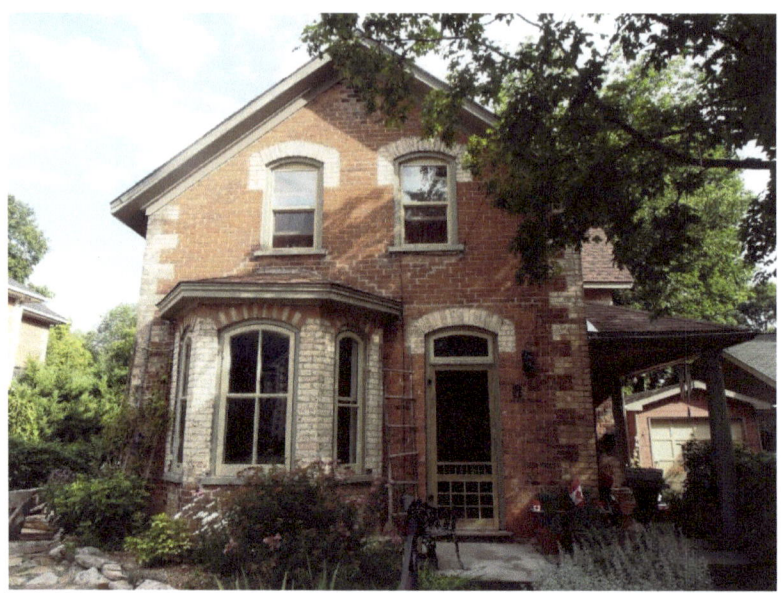
8 Church Street – Gothic Revival – steeply pitched gable

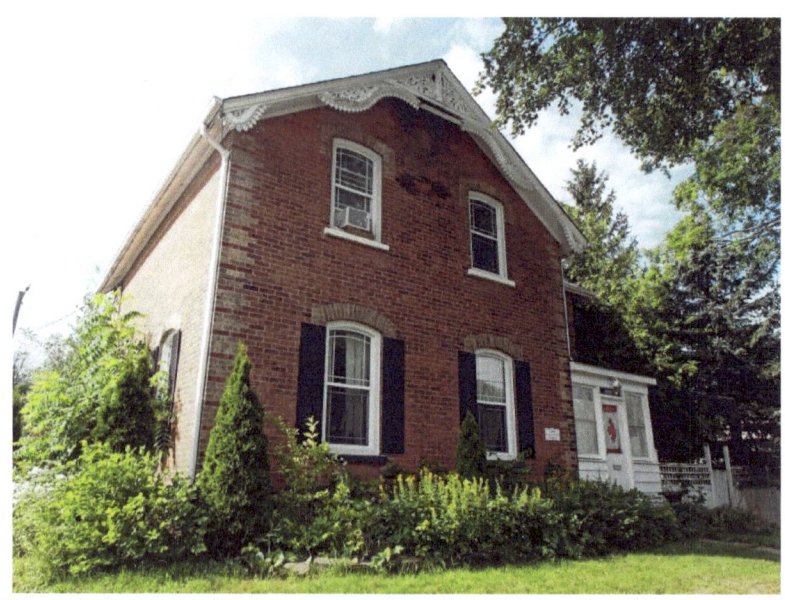
9 Church Street – Robert and Carrie Allen, Blacksmith c. 1886
Gothic Revival – Vergeboard trim on gable, corner quoins

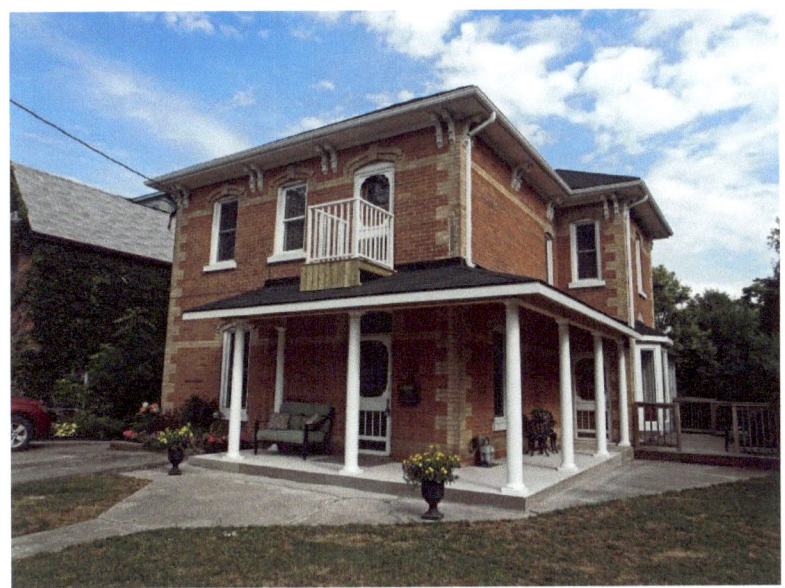

10 Church Street – Italianate – paired cornice brackets, dichromatic brickwork, quoining, balcony on 2nd storey

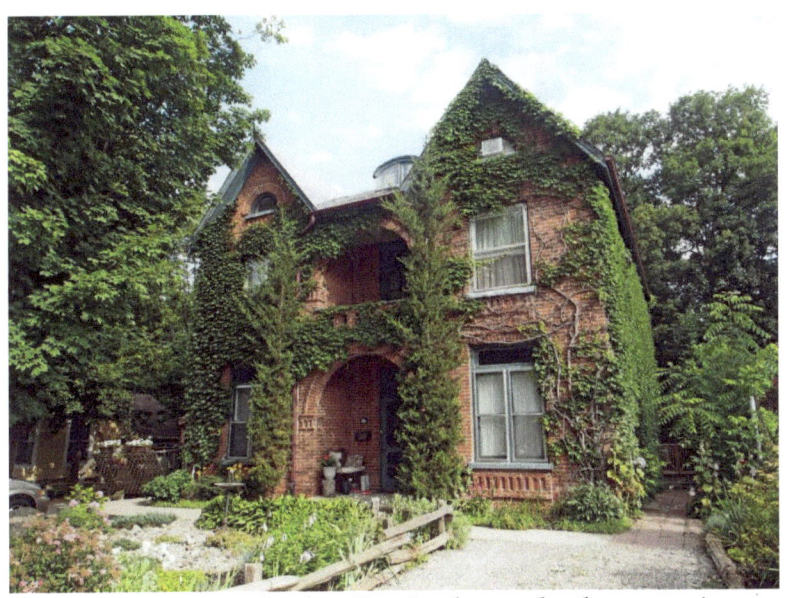

14 Church Street – Gothic Revival – arched voussoirs over windows and doorway

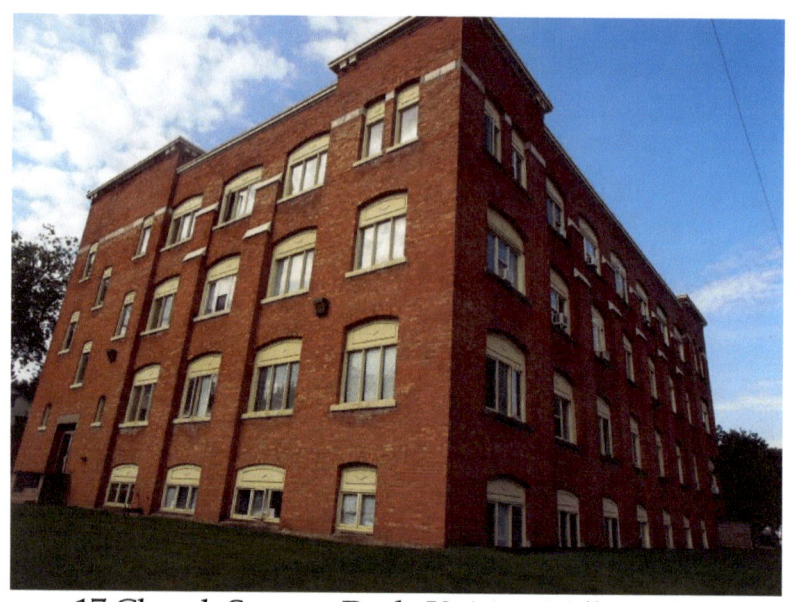

17 Church Street – Dods Knitting Mills c. 1913
Early Industrial Architecture

Armstrong Street

35 Armstrong Street – Canadian Pacific Railway Station – distinctive conical roof (witch's hat) covers former waiting room

Architectural Terms

Brackets: a decorative or weight-bearing structural element which forms a right angle with one side against a wall and the other under a projecting surface such as an eave or roof. Example: 26 York Street	
Cornice: originally the wooden overhang of the roof. With the use of stone, brick, iron and steel, the cornice is any projecting shelf at the top of a ceiling or roof. They can be very decorative. Example: 62 Mill Street	
Dichromatic brickwork: the use of two colours of brick, tile or slate to decorate a façade. Example: 11 Little York Street	
Dormer: (French for "sleep") a gable end window that pierces through the plane of a sloping roof surface to create usable space in the top floor or attic of a building by adding headroom. Example: 4 Bythia Street	
Gable: the triangular portion of a wall between the edges of a sloping roof. Example: 8 Bythia Street	
Hipped Roof: a roof where all sides slope downwards to the walls with no gables. Example: 11 York Street	
Keystones and Voussoirs: a voussoir is a wedge-shaped element used in building an arch. A keystone is the central stone that locks all the stones into position, allowing the arch to bear weight. A keystone is often enlarged and embellished. Example: 100 John Street	

Lancet Window: a tall, narrow window with a pointed arch at its top. Example: 100 John Street	
Mansard Roof: This style was popularized by Francois Mansart (1598-1666), an accomplished architect of the French Baroque period and especially fashionable during the Second French Empire (1852-1870). This roof is almost flat on the top section, with two slopes on each of its sides with the lower slope at a steeper angle than the upper and having dormer windows. Example: 16-18 Wellington Street	
Quoin: masonry blocks at the corner of a wall, often a decorative feature, usually larger or of a different colour than the rest of the wall. Example: 11 York Street	
Vergeboards: also called bargeboards – hang from the projecting end of a roof and are often elaborately carved and ornamented. Example: 16 York Street	

Orangeville's Building Styles

Edwardian, 1900-1930 – This style bridges the ornate and elaborate styles of the Victorian era and the simplified styles of the 20th century. Balanced facades, simple roof lines, dormer windows, large front porches, and smooth brick surfaces are its characteristics. Example: 6 York Street	
Georgian, before 1860 – This style began with the British King Georges in the 18th century. These buildings have balanced facades around a central door, medium-pitched gable roofs, and small paned windows. Example: 6 John Street	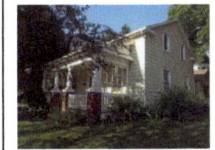
Gothic Revival, 1830-1890 – These decorative buildings have sharply-pitched gables with highly detailed vergeboards, pointed-arch window openings, and dichromatic brickwork. It is a common style in Ontario. Example: 19 York Street	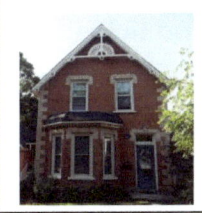
Italianate, 1850-1900 – It has wide-bracketed eaves, belvederes, wrap-around verandahs. Example: York Street	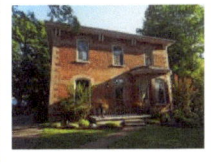

Queen Anne, 1885-1900 – This style is distinguished by an irregular outline featuring a combination of an offset tower, broad gables, projecting two-storey bays, verandahs, multi-sloped roofs, and tall, decorative chimneys. A mixture of brick and wood is common. Windows often have one large single-paned bottom sash and small panes in the upper sash. Example: 3 York Street	
Romanesque Revival, 1880-1910 – This style hearkens back to medieval architecture of the 11th and 12th centuries with a heavy appearance, blocky towers and rounded arches. Example: 2 York Street	
Second Empire, 1860-1880 – The mansard roof is the most noteworthy feature of this style and is evidence of the French origins. Projecting central towers and one or two-storey bays can also be present. Example: 16-18 Wellington Street	

www.ingramcontent.com/pod-product-compliance
Lightning Source LLC
Chambersburg PA
CBHW040856180526
45159CB00001B/437